UNIQUE
by DESIGN

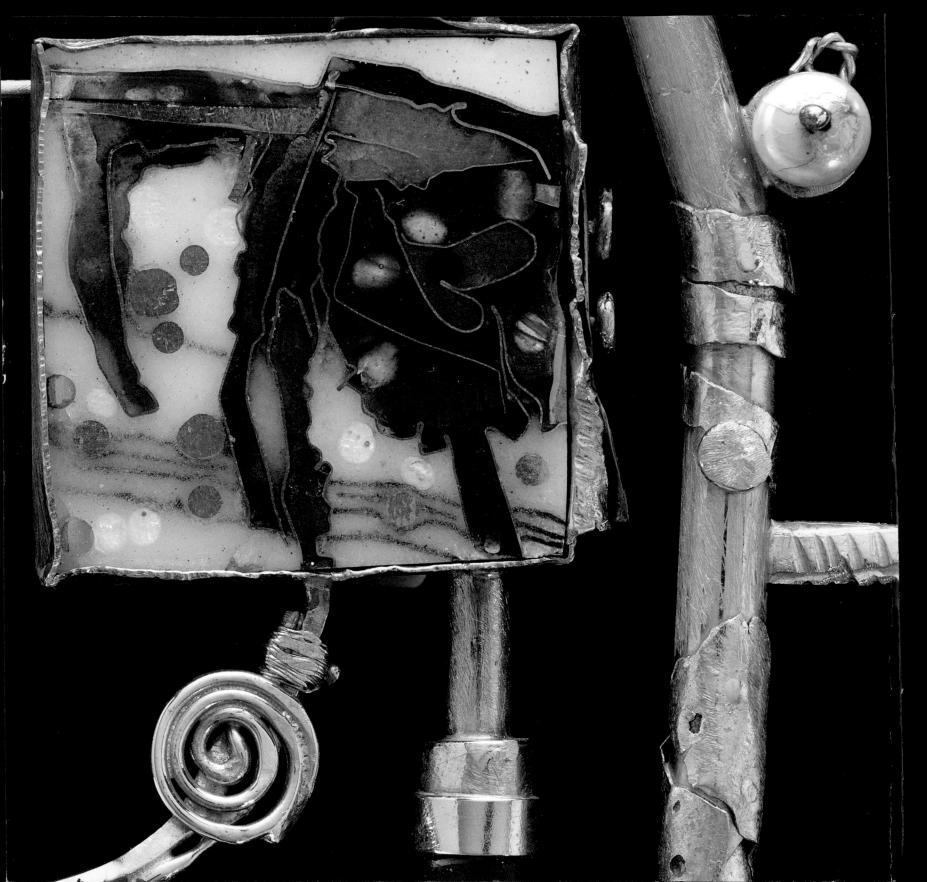

UNIQUE
by DESIGN

Contemporary Jewelry in the
Donna Schneier Collection

SUZANNE RAMLJAK

The Metropolitan Museum of Art, New York
Distributed by Yale University Press, New Haven and London

This catalogue is published in conjunction with "Unique by Design: Contemporary Jewelry in the Donna Schneier Collection," on view at The Metropolitan Museum of Art, New York, from May 13 through August 31, 2014.

This publication is made possible in part by the Dobkin Family Foundation, the Gorelick Family, the Rotasa Foundation, the Charles and Mildred Schnurmacher Foundation, Inc., and friends of Donna Schneier.

Published by The Metropolitan Museum of Art, New York
Mark Polizzotti, Publisher and Editor in Chief
Gwen Roginsky, Associate Publisher and General Manager of Publications
Peter Antony, Chief Production Manager
Michael Sittenfeld, Managing Editor
Robert Weisberg, Senior Project Manager

Edited by Alexandra Bonfante-Warren
Designed by Gina Rossi
Production by Peter Antony and Sally VanDevanter
Bibliography edited by Penny Jones
Image acquisitions and permissions by Jane S. Tai

Photographs of works in the Metropolitan Museum's collection are by Anna-Marie Kellen, The Photograph Studio, The Metropolitan Museum of Art, unless otherwise noted. Figures 2, 4, 8, 11, 12: © the artists; figure 9: Courtesy The Bridgeman Art Library © Succession Marcel Duchamp/ Artists Rights Society (ARS), New York 2014

Typeset in Museo Sans and Museo Slab
Printed on 150 gsm Gardamatt
Separations by Professional Graphics, Inc., Rockford, Illinois
Printed and bound by Conti Tipocolor, S.p.A., Florence, Italy

Cover illustrations: front, Manfred Bischoff, *Monte Fiascone*, 1988 (detail, p. 102); back, Hermann Jünger, Brooch, ca. 1970–72 (detail, p. 84)

Frontispiece: William Harper, *Homage to Cy Twombly and Joseph Cornell*, ca. 1994 (detail, pp. 54–55); page 6: Pavel Opocenský, *Art*, ca. 1988–89 (detail, p. 58); page 9: Vera Siemund, *Shadows*, 2003 (detail, p. 97); page 10: Peter Skubic, Brooch, 1995 (detail, p. 59); p. 14: Attai Chen, Necklace, 2011 (detail, p. 126); page 136: Bettina Dittlmann, Brooch, ca. 2003 (detail, p. 75)

The Metropolitan Museum of Art
1000 Fifth Avenue
New York, New York 10028
metmuseum.org

Distributed by Yale University Press, New Haven and London
yalebooks.com/art
yalebooks.co.uk

Cataloguing-in-Publication Data is available from the Library of Congress.
ISBN 978-1-58839-554-2 (The Metropolitan Museum of Art)
ISBN 978-0-300-20876-4 (Yale University Press)

CONTENTS

7 DIRECTOR'S FOREWORD

11 INTRODUCTION

15 SEDUCTIVE TACTICS Contemporary Jewelry in the Donna Schneier Collection

81 PLATES

129 LIST OF WORKS

135 SELECTED READINGS

DIRECTOR'S FOREWORD

The collection of post–World War II jewelry assembled by Donna Schneier chronicles the history of modern and contemporary jewelry worldwide. Her gift to The Metropolitan Museum of Art of 132 necklaces, bracelets, brooches, earrings, and rings created by 88 makers embodies an era in which artists and craftspeople experimented with new materials, techniques, and concepts.

The artists represented in the Donna Schneier Collection conceived their works within larger artistic movements, signaling a period in which concepts and ideas were valued more than precious materials. They were inspired by important turn-of-the-twentieth-century jewelers such as René Lalique and Louis Comfort Tiffany, but also looked to artists like Alexander Calder—who began making jewelry in the 1930s—and midcentury modernists like Art Smith and Sam Kramer. Abstraction, Conceptual art, and Minimalism were all powerful influences, along with earlier modernist movements such as the Bauhaus and De Stijl. Performance

art, Pop art, and a keen interest in narrative and figurative work also came into play.

I want to acknowledge Associate Curator Jane Adlin, who has worked closely with Donna Schneier on the installation and publication of this collection. This volume and the exhibition it accompanies are part of the Met's ongoing series of projects focusing on modern and contemporary design. Indeed it is a pleasure to add the Donna Schneier Collection to this distinguished series, as her discerning eye and her abundant generosity have greatly enhanced the Met's design holdings.

THOMAS P. CAMPBELL
Director
The Metropolitan Museum of Art

INTRODUCTION

Collectors come in many guises. Some assume the role accidentally, realizing only in retrospect what they have amassed. Others are intent from the start but guided by vague or personal criteria. Still others stay focused on means and ends, gleaning objects with a clear aim in mind. Donna Schneier exemplifies this third type, the strategic collector. That is not to say she lacks passion. Indeed, her superb collection of contemporary jewelry was born from a merger of ardor and diligence.

Schneier's gift of art jewelry to The Metropolitan Museum of Art is more a tribute to this creative field than to her own individual taste. As Schneier has stated, "My goal was to document as best I could the significant artists and movements . . . irrespective of my likes and dislikes."[1] Accordingly, her donation of 132 jewelry pieces is not marked by a particular style or conceptual bent. Schneier approached collecting as a chronicler of avant-garde jewelry from the 1960s to the present, seeking to acquire seminal works that have advanced the evolution of this art form. Comprising examples

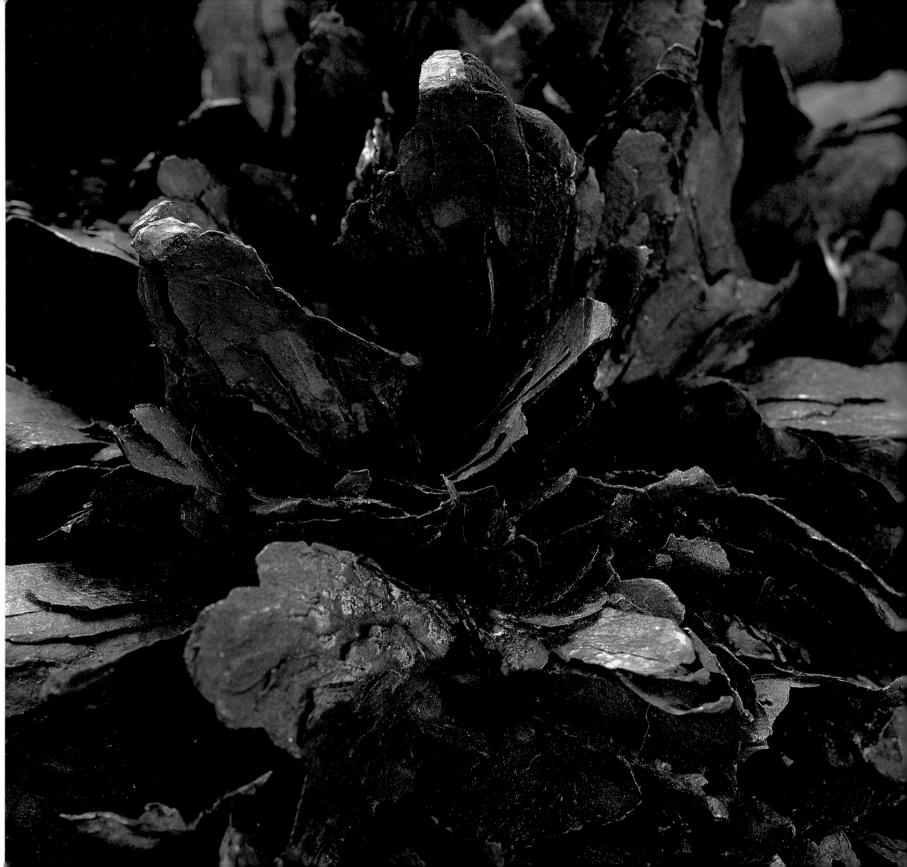

SEDUCTIVE TACTICS
Contemporary Jewelry in the Donna Schneier Collection

When humans first strung shells around their necks some one hundred thousand years ago, they heralded the dawn of symbolic ornament and our species's self-awareness. This primal act of adornment is now taken as proof that early Homo sapiens had already established a complex system of symbols, distinguishing us from other animals.[1] "The common element among such ornaments is that they transmit meaning to others," states the archaeologist Francesco d'Errico. "They convey an image of you that is not just your biological self."[2] Indeed, jewelry is tightly bound with symbolism, and its use implies a developed sense of identity. As such, jewelry has always played a principal role on the social stage and offered ripe opportunity for individual expression.

Today, thousands of years hence, when we don a necklace, ring, or cuff, we engage in the same process of cultural communication and personal assertion. The contemporary jeweler Bruno Martinazzi affirms this key dynamic: "If a human being wears jewelry, he is expressing symbolically his need for transforming himself: not merely superficially . . . but profoundly transforming himself and his life."[3] While the urge to remake oneself through artifice and adornment remains constant, the options available to jewelers and wearers have grown ever more varied. Over the millennia, this practice has evolved and expanded, assuming fresh tactics and forms, from the earliest pigmented seashells to the 3-D-printed plastics of our age.

Against the vast backdrop of human history and ornamental array, the past few decades may seem a mere flash. Although brief, this period has witnessed epic change and prolific output within the jewelry medium. Building on the rich legacy of human embellishment, contemporary jewelers also depart from tradition in decisive ways. While this essay does not chart the countless shifts through the eons, it does highlight the traits that unite and divide recent jewelry from its bright antecedents.

1. Robert G. Bednarik, "Beads and the Origins of Symbolism," *Time and Mind: The Journal of Archaeology, Consciousness and Culture* 1, no. 3 (2008), pp. 285–318.
2. Francesco d'Errico, cited in Kathleen Wren, "Tiny Shells May Be World's Oldest Beads," in *Today Tech* (June 22, 2006); http://www.today.com/id/13483253/ns/technology_and_science-science.
3. Bruno Martinazzi, quoted in *Bruno Martinazzi: Schmuck, Gioielli, Jewellery 1958–1997*, exh. cat. (Stuttgart: Arnoldsche Art Publishers, 1997), p. 52.

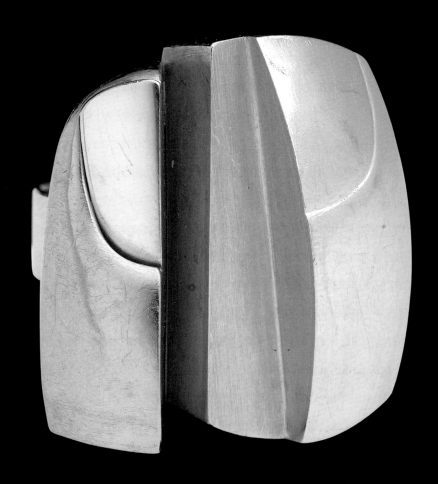

BRUNO MARTINAZZI
Eco, 1992
Ring
20K gold and white gold

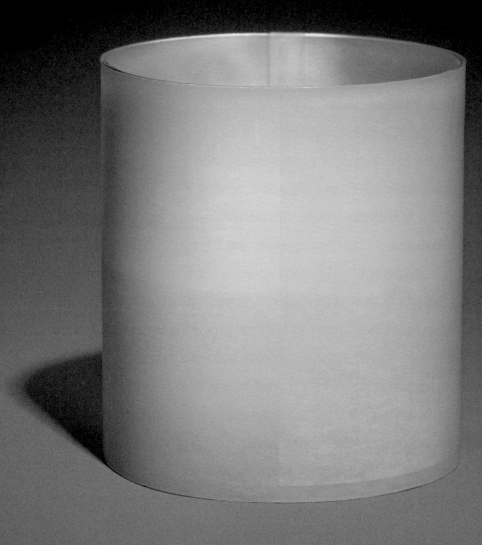

EMMY VAN LEERSUM
Armband, ca. 1970
Resin

22

both radicals. Jünger defied convention by adopting an intuitive approach to traditional goldsmithing, and Van Leersum by harnessing unconventional materials to expand the bounds of body ornament. Each sought freedom from precedent, and each paved a path for succeeding generations.

The question of materials has been central to efforts to assert jewelry's cultural import and artistic range. A form of wearable currency, jewelry has long served as a visible expression of wealth, just as coins have been commonly used as adornment around the world. Gold and money are interchangeable—thus the gold standard, as well as the fate of many jewels, today imprisoned in bank vaults awaiting future tender. In reaction, avant-garde jewelers shunned materials with inherent value, demanding instead recognition for extramonetary assets such as ideas, ingenuity, and experiential rewards.

Many people still see dollar signs when they look at jewelry, especially engagement rings, remaining oblivious to qualities of concept or design. Oscar Wilde's Lord Darlington quipped that a cynic "knows the price of everything, and the value of nothing,"[7] a view that is particularly apt for popular perceptions of jewelry. *Priceless Charm Bracelet* (1999; fig. 2),

7. Oscar Wilde, *Lady Windermere's Fan: A Play about a Good Woman* (1892; London: Elkin Mathews and John Lane, 1893).

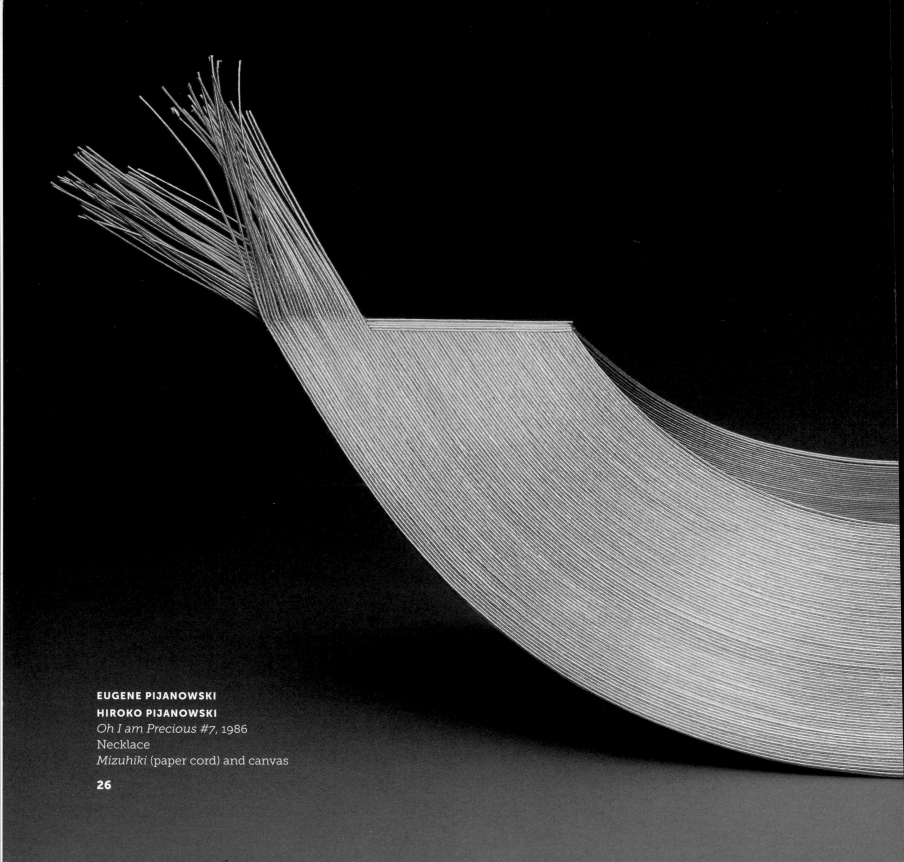

EUGENE PIJANOWSKI
HIROKO PIJANOWSKI
Oh I am Precious #7, 1986
Necklace
Mizuhiki (paper cord) and canvas

26

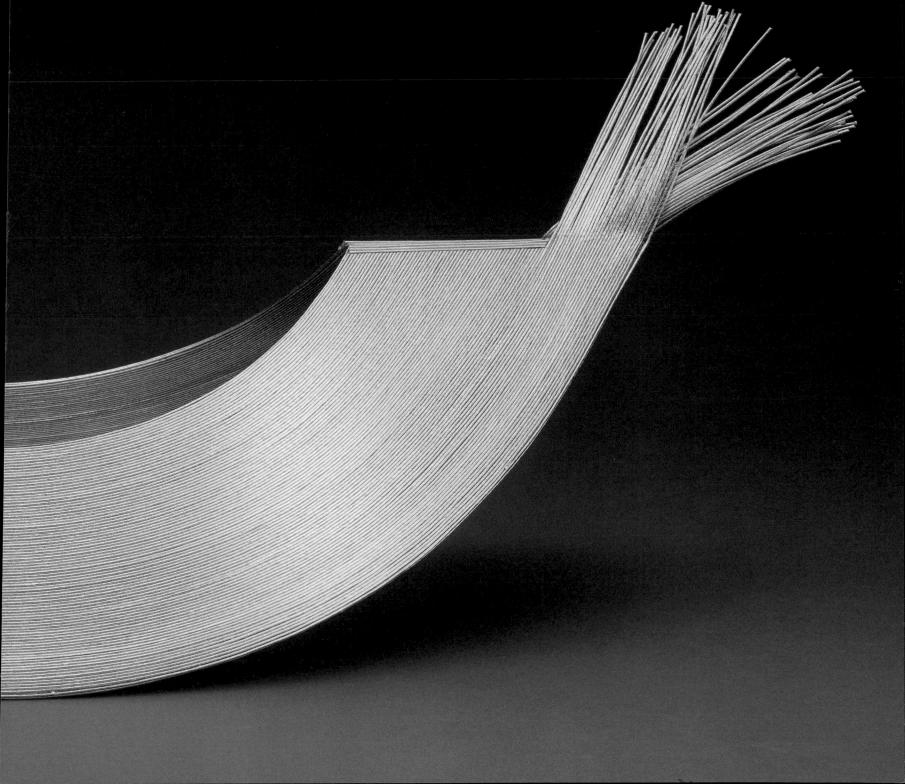

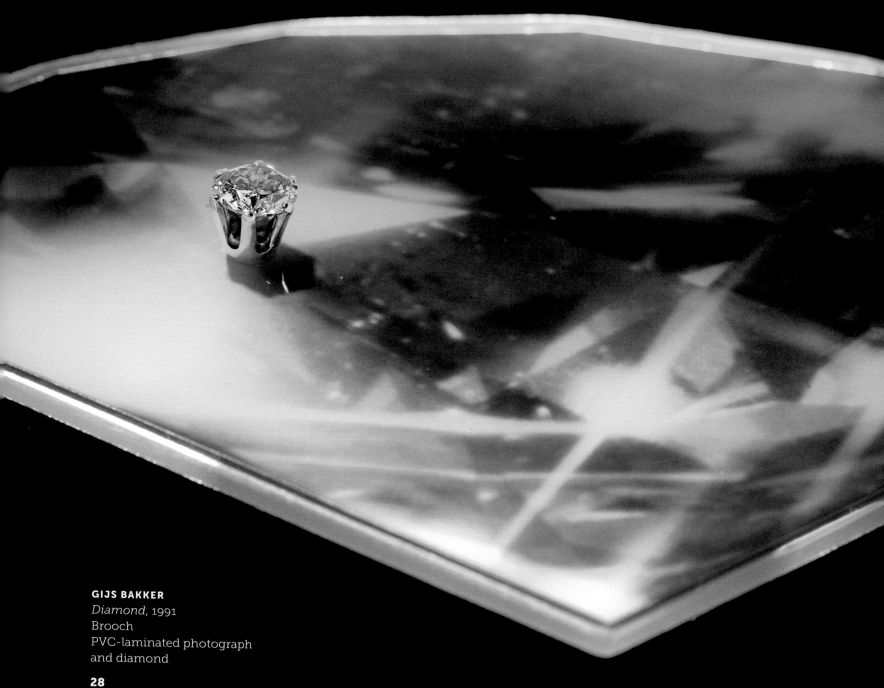

GIJS BAKKER
Diamond, 1991
Brooch
PVC-laminated photograph
and diamond

28

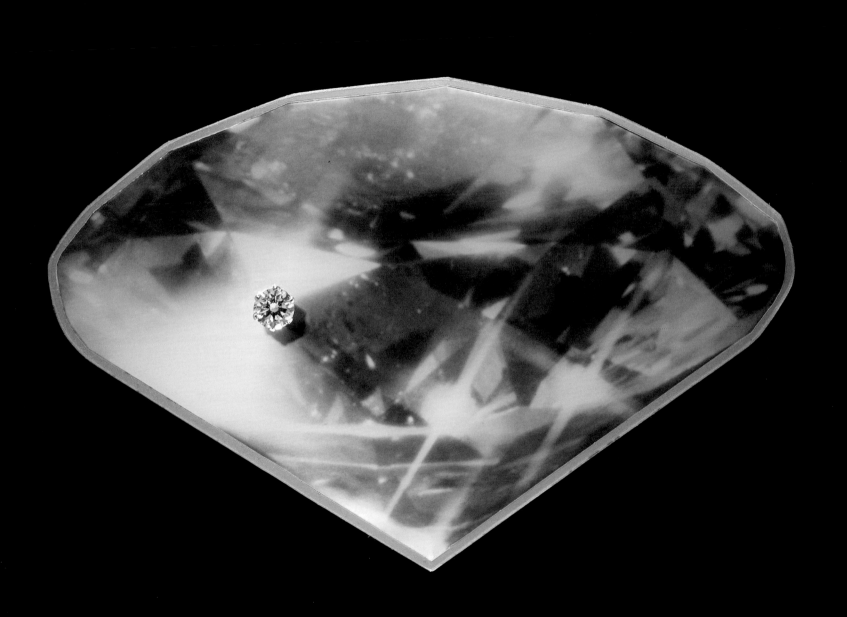

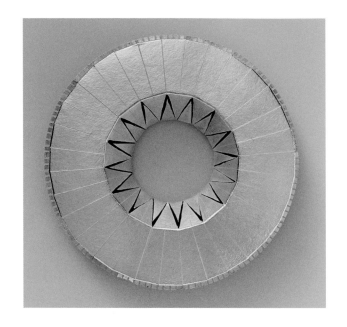

Fig. 5. Lisa Gralnick (American, b. 1956). Brooch, 2000. 18K gold, Diam. 2¾ in. (7 cm). The Metropolitan Museum of Art, New York, Gift of Donna Schneier, 2007 (2007.384.17)

The early attacks by art jewelers on staid conventions successfully flung open the doors of possibility, not only in the areas of materials and values, but also in regard to jewelry's functions and strategies. Although some ornament does have a practical use, as a fastener or container, for example, jewelry's main job is symbolic; it conveys meaning in the world. Within the forums in which jewelry participates— social, personal, ritual—it acts to transmit signals about power, status, memory, sentiment, courtship, and other affiliations. While jewelry still fulfills the many tasks it has performed throughout the centuries, these are given new twists by contemporary artists.

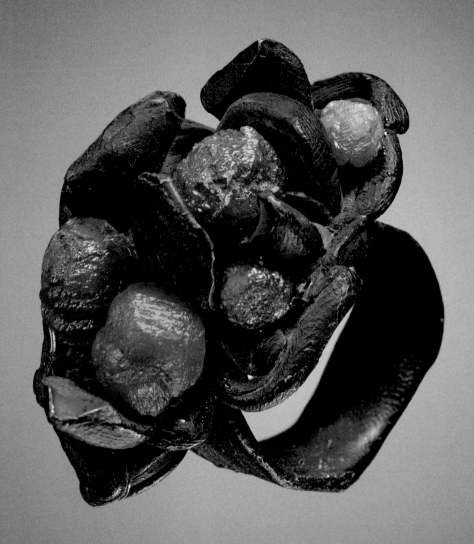

KARL FRITSCH
Ring, 2005
Oxidized silver and rough diamonds

33

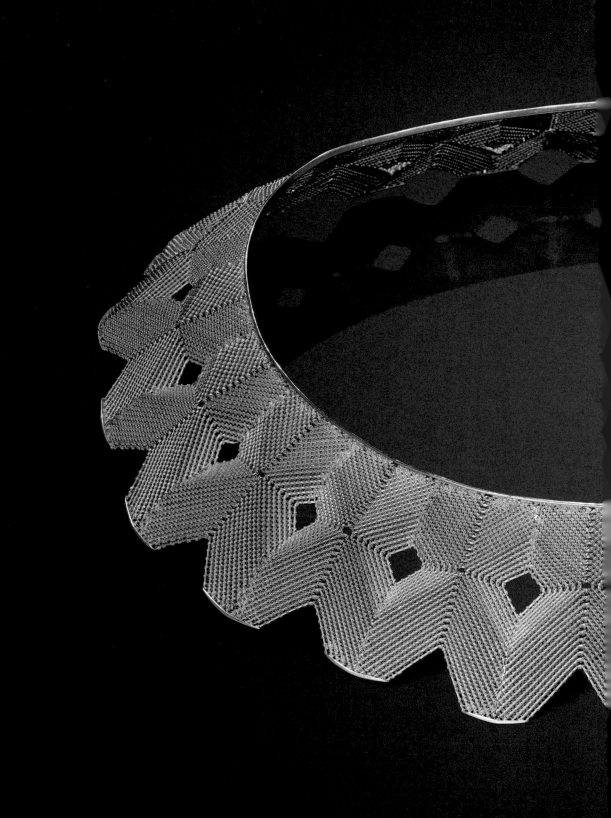

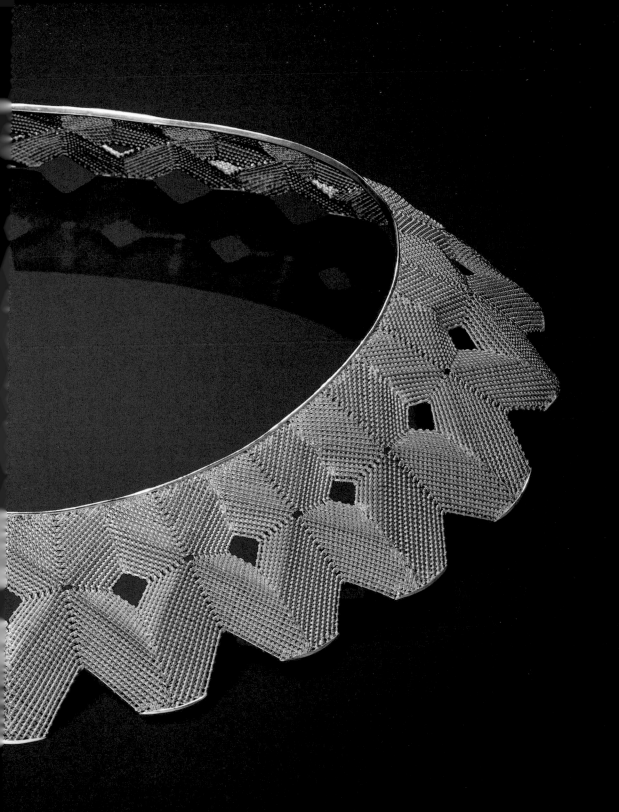

MARY LEE HU
Choker #70, 1985
Necklace
18K gold and 22K gold

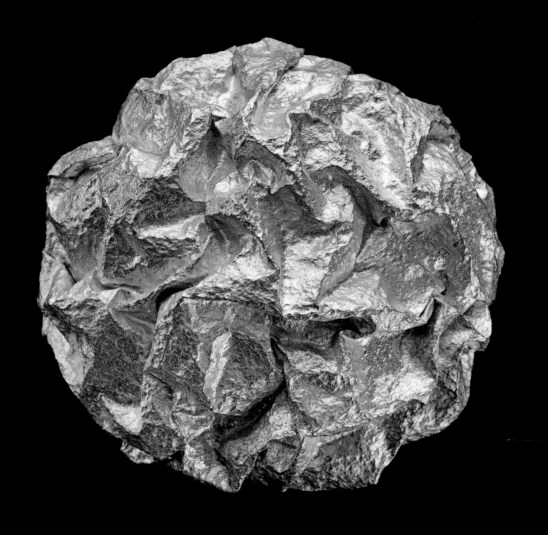

HIRAMATSU YASUKI
Brooch, ca. 1976
Gold

36

One of the most ancient and poignant uses of jewelry has been as a means of deflecting harm. Within this protective, or apotropaic, category, we find charms, amulets, and talismans designed to ward off evil or prevent bad luck. These faith-imbued ornaments are invested with magical properties by the creator and the owner and, at a minimum, grant the wearer a modicum of confidence. Jewelry's portability, tactility, and proximity to the body give it a distinct advantage in eliciting a sense of well-being. William Harper's *Magic Beads* (1984), while not part of a specific ritual or religion, descends from this line of adornment. Some forms of protective ornament merge physical and symbolic safeguarding traits. Kiff Slemmons's neckpiece *Sticks and Stones and Words* (1992) updates Plains Indian hairpipe breastplates, which were thought of as magical armor when worn in battle. Slemmons's version features pencils instead of bones, a reference to the false protection that written treaties gave to native peoples. Like many contemporary riffs on traditional jewelry, this piece goes beyond replication to offer commentary on the functional format itself.

Jewelry has also played an essential role both in mourning and in tempering the pain of loss. Through the use of photos, symbols, and property from the dead, bereaved wearers can tangibly summon the presence of the deceased.

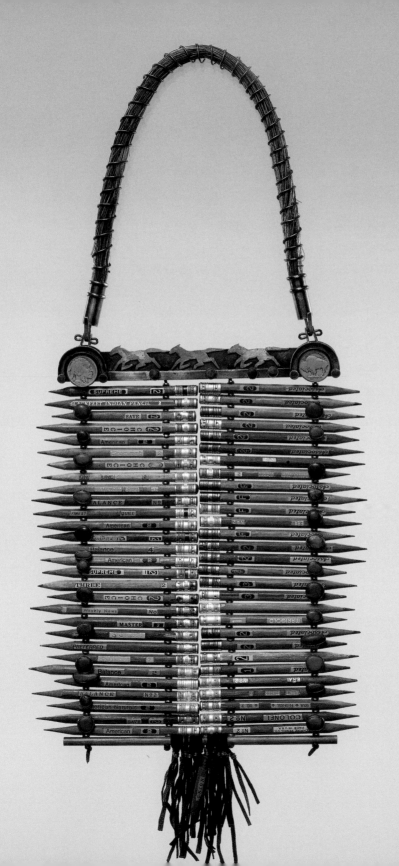

KIFF SLEMMONS

Sticks and Stones and Words, 1992
Breastplate
Silver, pencils, erasers, stone,
horsehair, coins, and leather

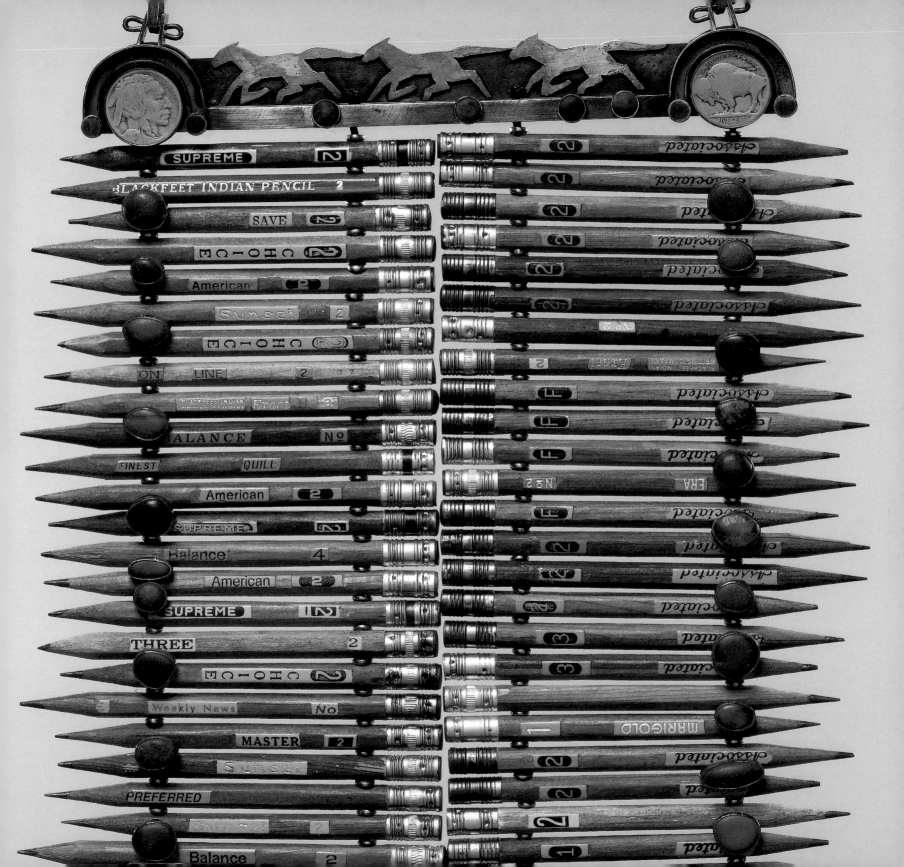

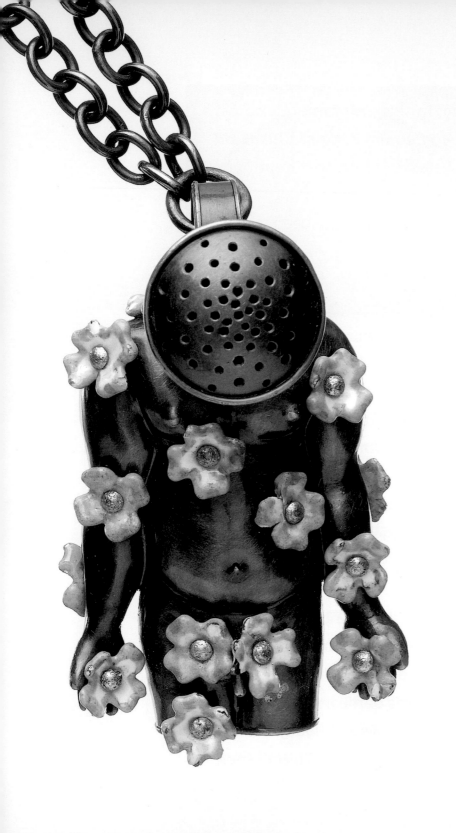

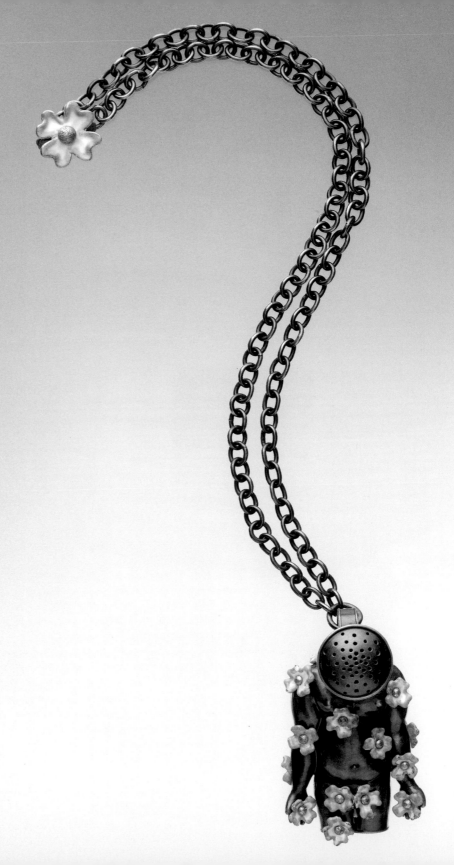

KEITH LEWIS
Bloom, 1998
Necklace
Silver, gold leaf, and enamel

43

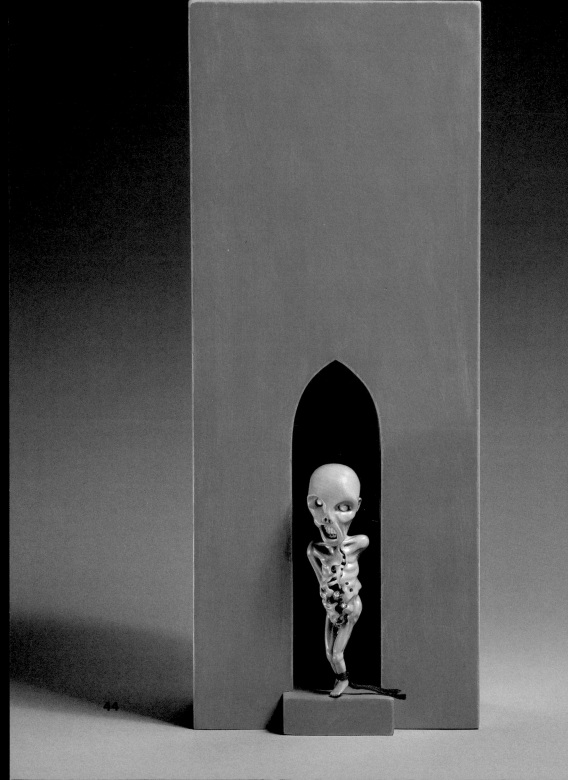

44

BRUCE METCALF
Memento Mori, 2001
Brooch with stand
Brooch: boxwood, diamonds, 18K
gold, and cotton thread
Stand: painted basswood

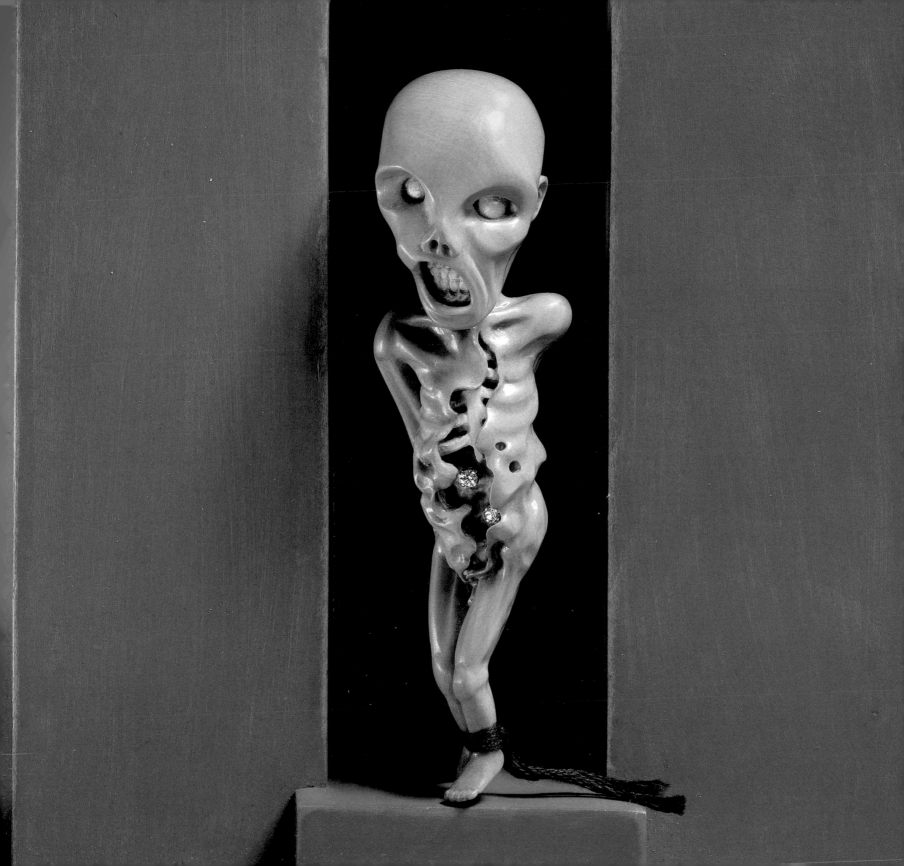

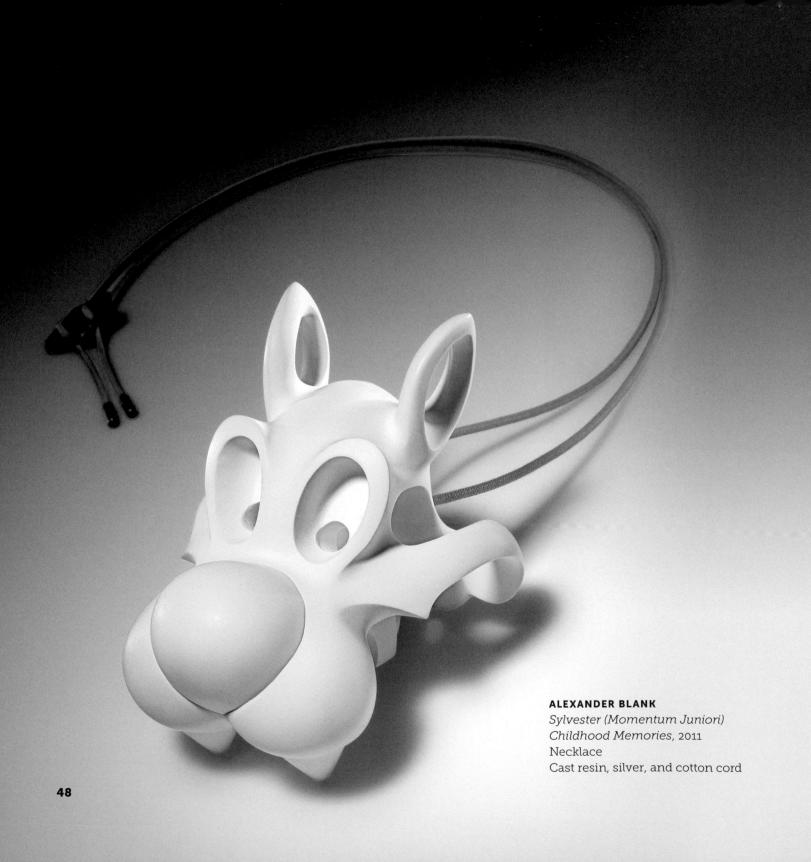

ALEXANDER BLANK
Sylvester (Momentum Juniori)
Childhood Memories, 2011
Necklace
Cast resin, silver, and cotton cord

48

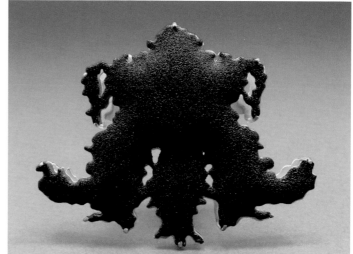

as this—or suggestively abstract brooches by Pavel Opocenský (fig. 7) and others— could be likened to the Rorschach inkblots that solicit personal projection and interpretation. The correlation between art jewelry and these amorphous graphics is emphasized in Amelia Toelke's 2005 brooch series based on the diagnostic tests (fig. 8). Such coy evocation and tactical elusiveness are marks of much contemporary art, and recent studio jewelry joins in this provocation.

Fig. 7. Pavel Opocenský (Czech, b. 1954). Brooch, ca. 1985. Ivory and wood, 1¾ × 2 in. (4.4 × 5.1 cm). The Metropolitan Museum of Art, New York, Gift of Donna Schneier, 2007 (N.A.2007.168)

Fig. 8. Amelia Toelke (American, b. 1983). *Rorschach Brooch #4*, 2005. Enamel on copper, and sterling silver, 3 × 2½ in. (7.6 × 6.4 cm). Collection of the artist

The ongoing rapport between jewelers and other art forms is relevant to a discussion of contemporary work. As part of a wider material culture, the medium overlaps other visual arts in its content and stylistic tendencies. Some jewelers are in open dialogue with other artists, as announced in

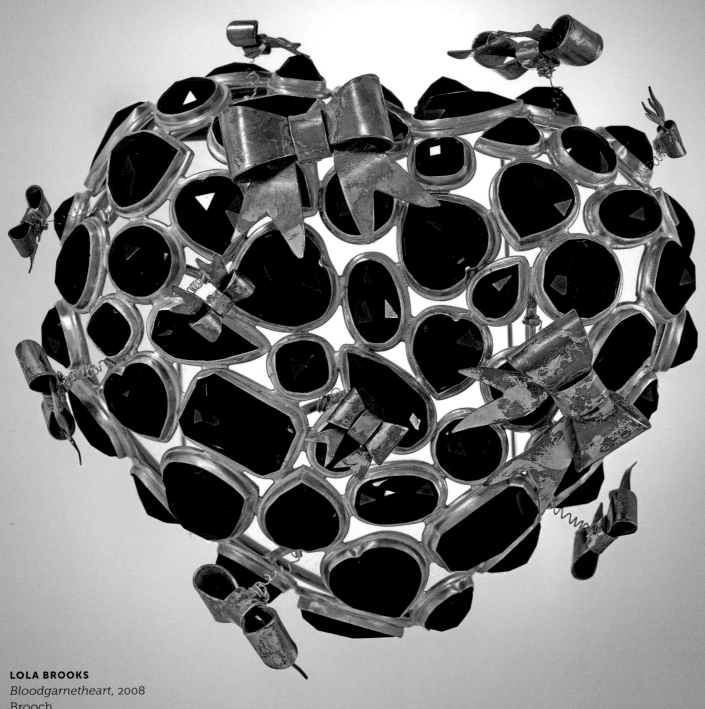

LOLA BROOKS
Bloodgarnetheart, 2008
Brooch
Gold, silver, and garnet

50

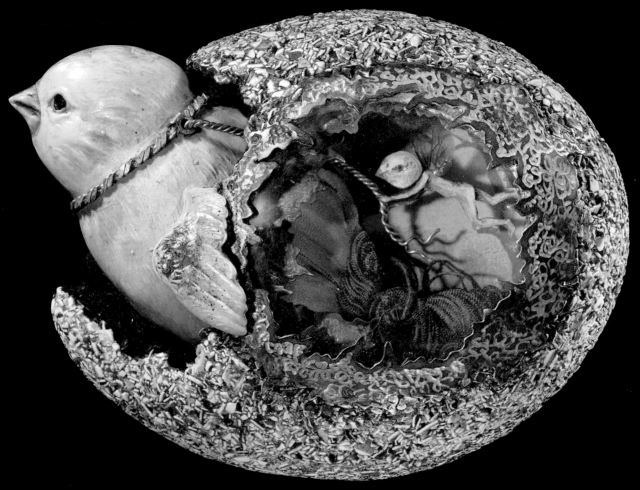

ROBIN KRANITZKY
KIM OVERSTREET
Ambiguity, 2005
Brooch
Eggshell, brass, Micarta, string,
copper, glass bead, flocking,
postcard fragments, insect wings,
celluloid, and found objects

51

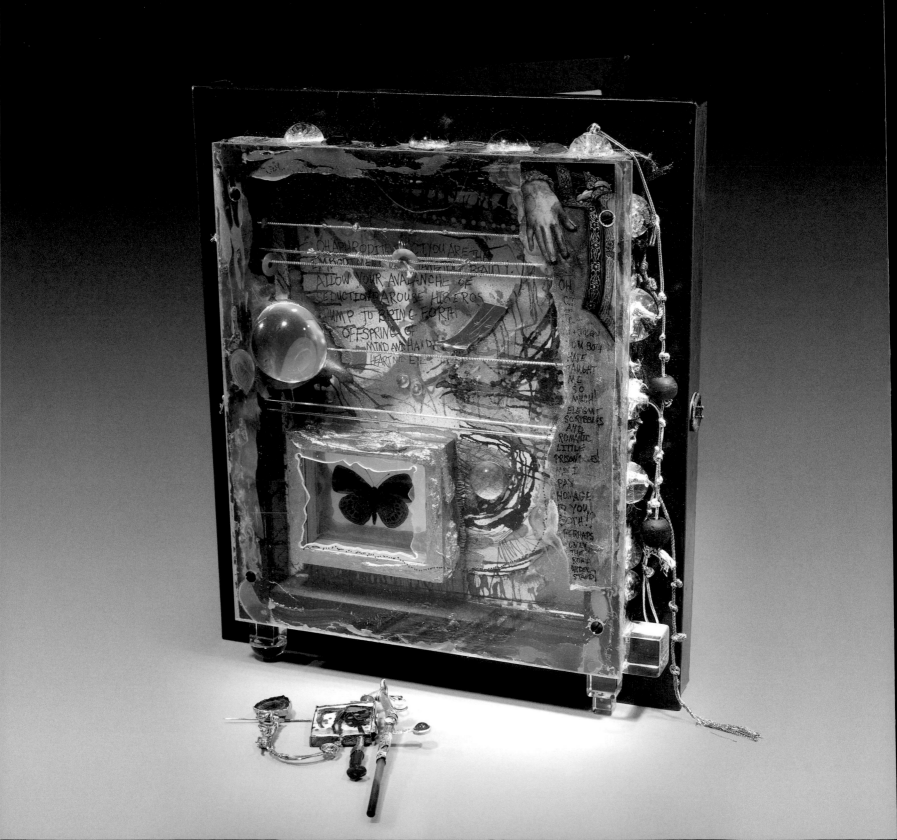

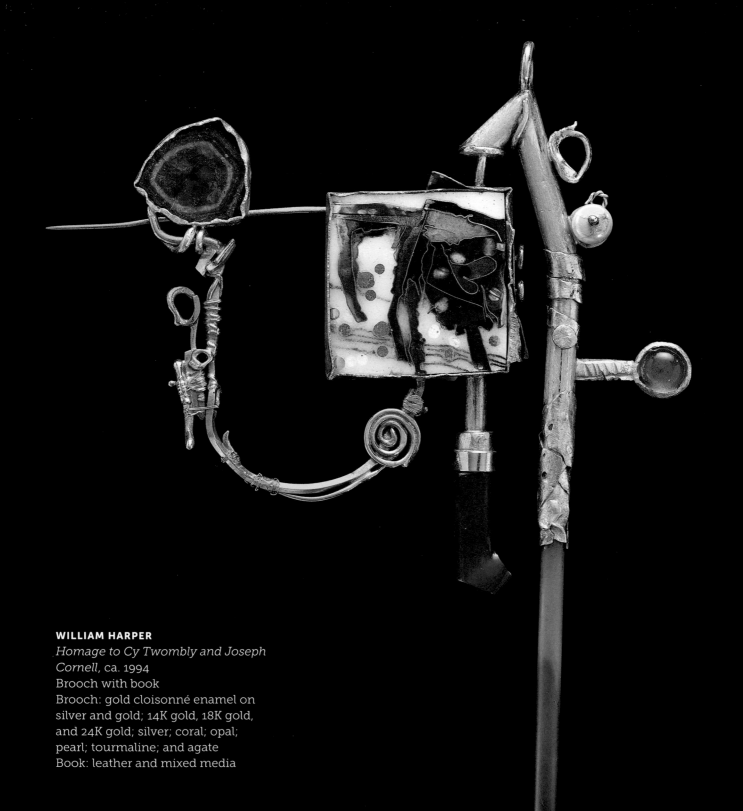

WILLIAM HARPER
*Homage to Cy Twombly and Joseph
Cornell*, ca. 1994
Brooch with book
Brooch: gold cloisonné enamel on
silver and gold; 14K gold, 18K gold,
and 24K gold; silver; coral; opal;
pearl; tourmaline; and agate
Book: leather and mixed media

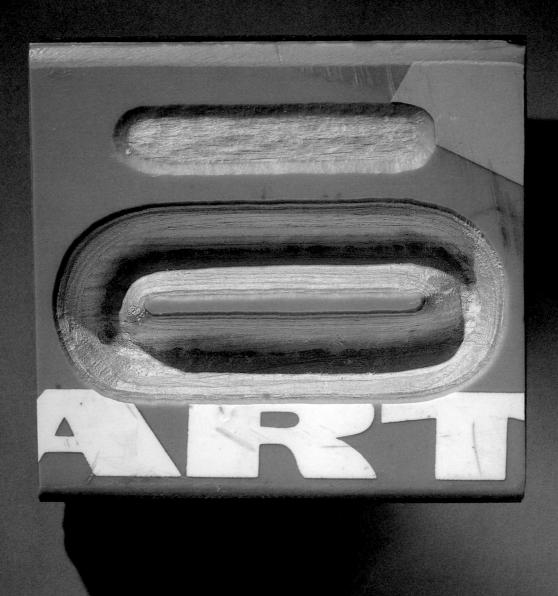

PAVEL OPOCENSKÝ
Art, ca. 1988–89
Brooch
Carved wood skis

58

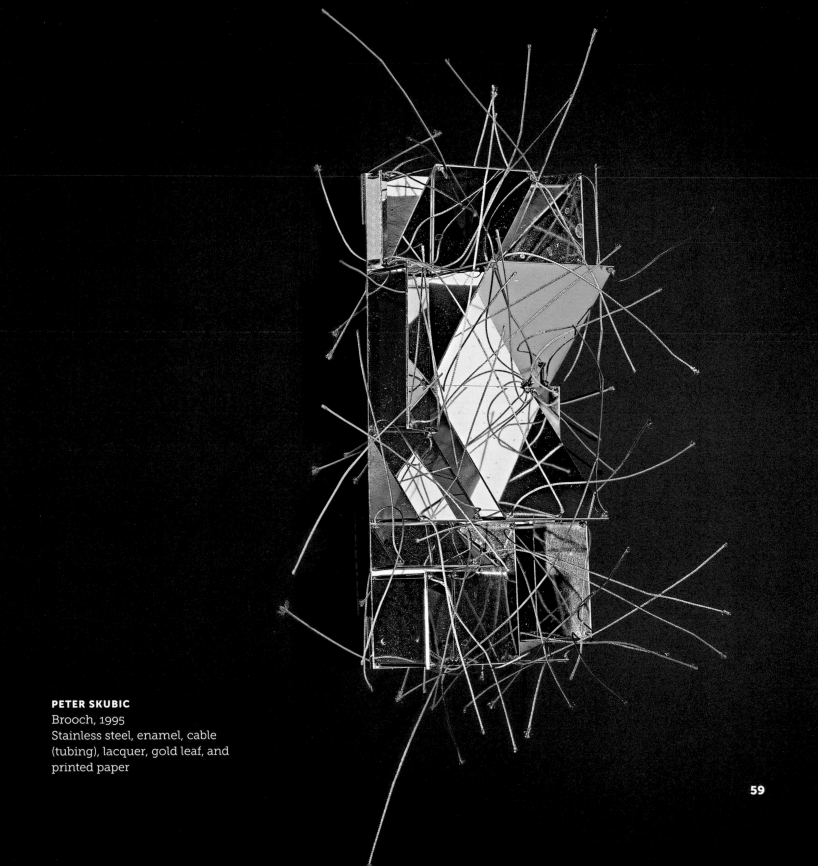

PETER SKUBIC
Brooch, 1995
Stainless steel, enamel, cable
(tubing), lacquer, gold leaf, and
printed paper

59

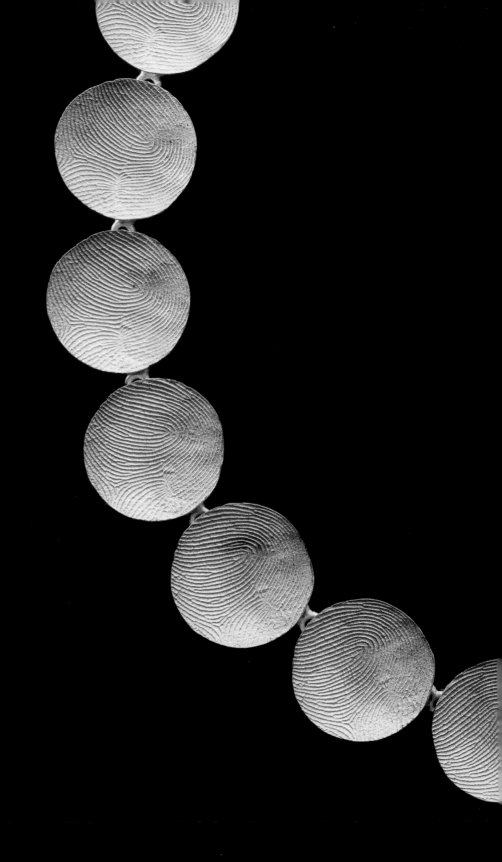

GERD ROTHMANN
From My Fingertips, ca. 1988
Necklace
18K gold

62

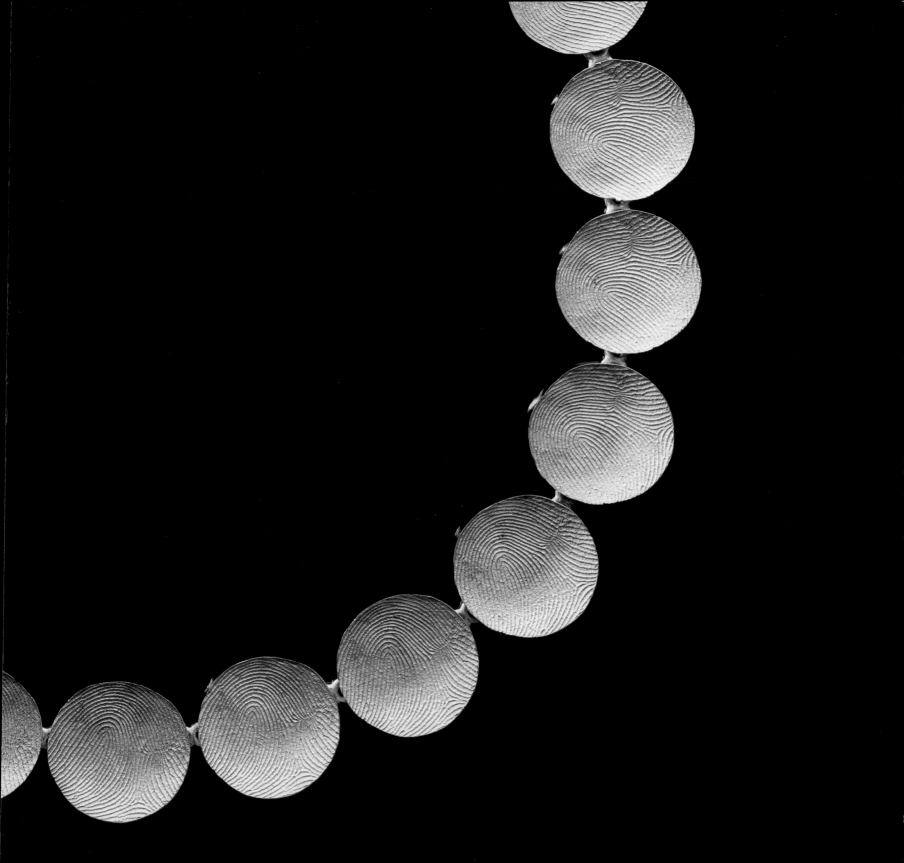

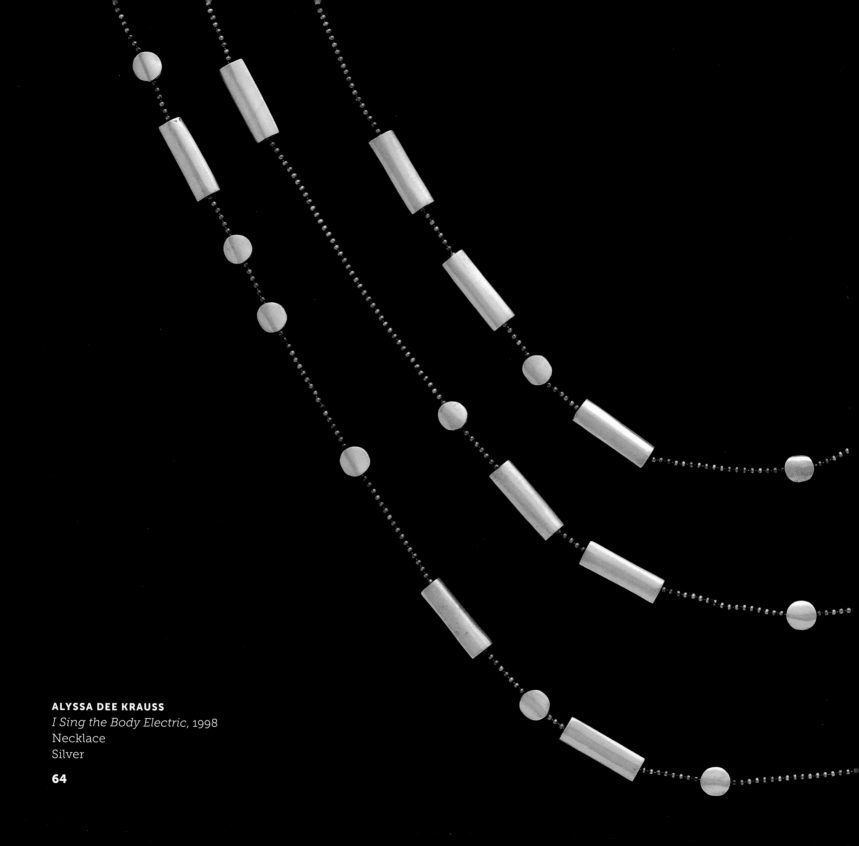

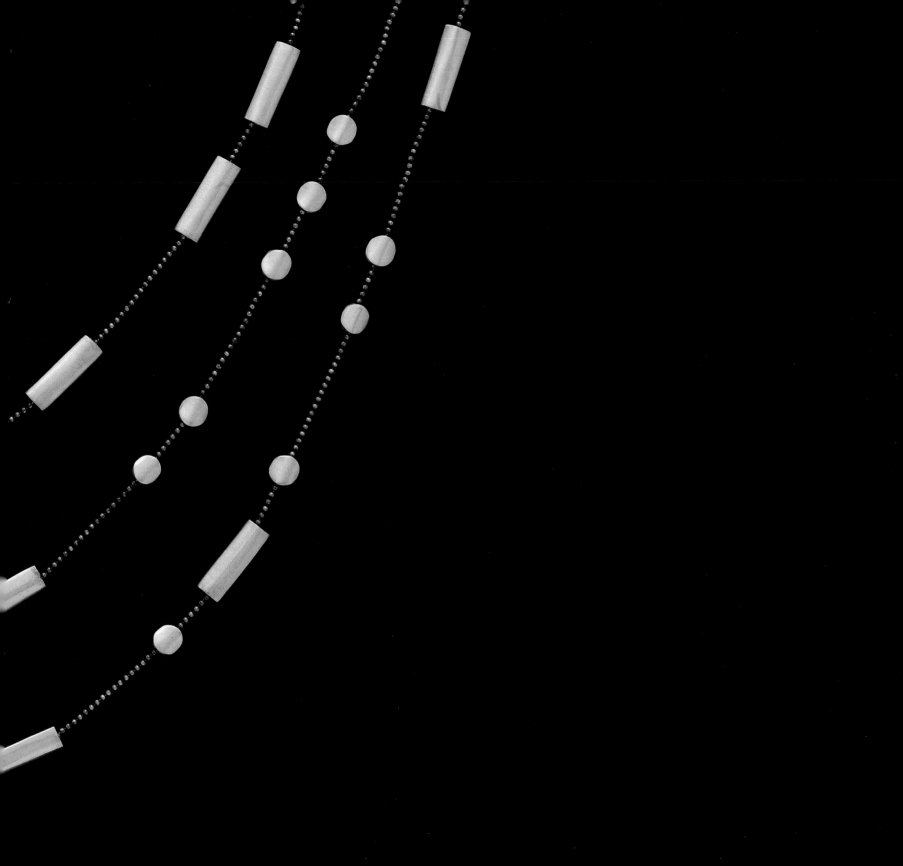

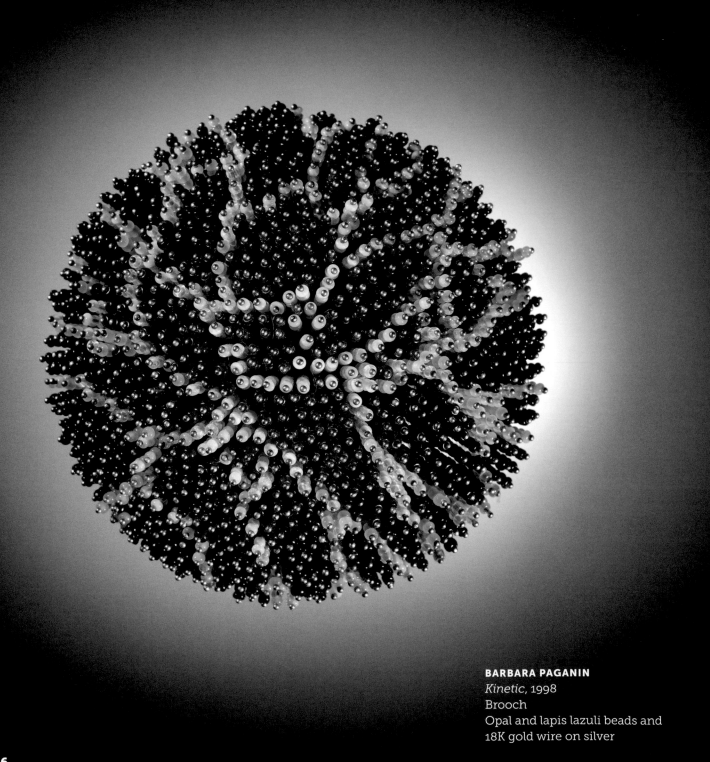

BARBARA PAGANIN
Kinetic, 1998
Brooch
Opal and lapis lazuli beads and
18K gold wire on silver

66

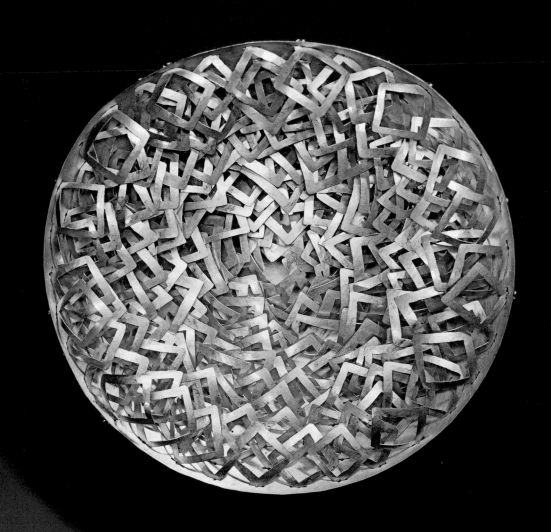

JACQUELINE RYAN
Kinetic, 2001
Brooch
18K gold

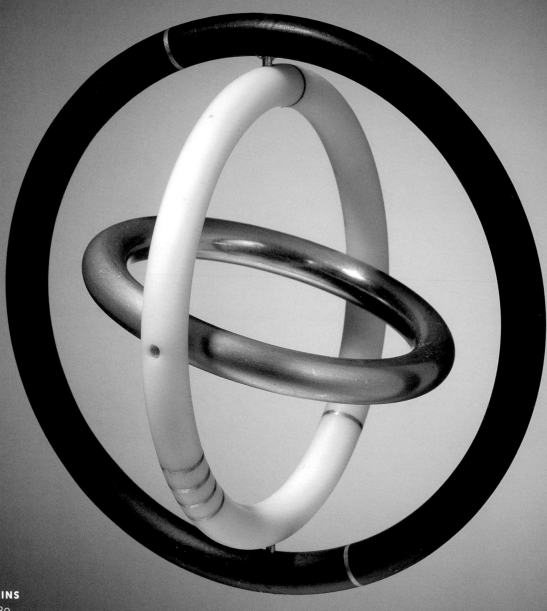

DAVID WATKINS
Gyro, ca. 1980
Bracelet
Aluminum, acrylic, and gold

68

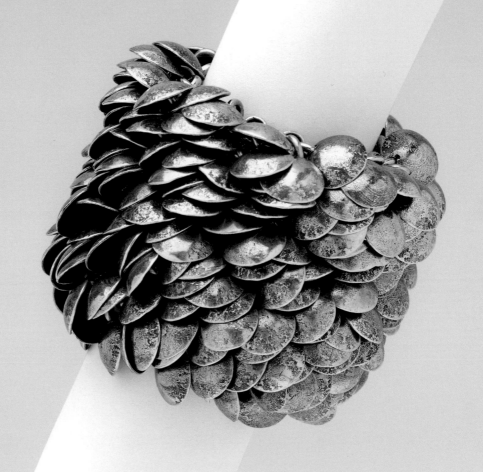

TONE VIGELAND
Ring, 1994
Silver

At its most sophisticated, it stages an intimate dance of attraction and manipulation—a ménage à trois among wearer, viewer, and ornament. The best contemporary jewelers know this routine and strategically compose work that seduces both wearer and viewer. It is worth noting that the root of "seduction" is the Latin *ducere*, meaning to lead or bring forth. Seductive objects arouse our awareness and entice us toward unintended ends. This intricate play of beauty and desire is enacted in Sondra Sherman's diptych neckpiece *Venus and Cupid* (1991–93), which brackets the wearer between adornments of attraction and love. Such jewelry raises the curtain on a careful choreography of attention.

Though the dynamics of seduction are not everywhere the same, they inevitably involve a degree of resistance. In the realm of fashion, the illustrious *Vogue* editor Diana Vreeland pronounced: "Elegance is refusal, and refusal is seductive." This element of denial is crucial to an ornament's pull, especially in contemporary jewelry, which tends to resist possession and comprehension on various levels. The anthropologist Alfred Gell also located opposition at the root of human attraction and found desire to be proportionate to the unyieldingness of its object.[11] Within ethnography, as with artworks, this resistance is experienced cognitively. Gell

11. Alfred Gell, "The Technology of Enchantment and the Enchantment of Technology," in *Anthropology, Art and Aesthetics*, edited by Jeremy Coote and Anthony Shelton (New York: Oxford University Press, 1992), pp. 40–63, esp. p. 58.

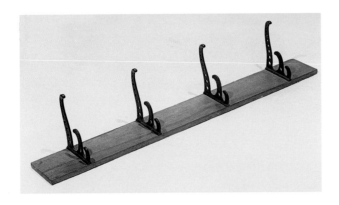

Fig. 9. Marcel Duchamp (American, b. France, 1887–1968). *Trap* (*Trébuchet*), 1917; replica 1964. Assisted readymade: coatrack. Mixed media, 7½ × 39½ × 4⅝ in. (19 × 100.1 × 11.6 cm). Israel Museum, Jerusalem, The Vera and Arturo Schwarz Collection of Dada and Surrealist Art in the Israel Museum (B72.0529)

saw the cultivation and deployment of impenetrable patterns as part of a culture's "technology of enchantment," designed to attach people to objects.[12] Unable to decipher a complex composition, the intellect is disarmed and ultimately surrenders—a victim in the game of psychological warfare. When one submits to the allure of an intricate pattern, one is liable to get hooked and ensnared.

This notion of ornament as obstacle or sticking point—a web in which we become enmeshed—is a fruitful framework for considerations of jewelry. Interestingly, adornment is referred to as "trappings," and several words that signify "capture" also apply readily to jewelry: captivating, alluring, charming, transfixing, stunning, gripping. It is also significant that Marcel Duchamp, the godfather of conceptual art, chose to title one of his sculptures *Trap* (*Trébuchet*; fig. 9), after a self-defeating chess strategy. Duchamp's 1917 readymade

12. Ibid.; see also Alfred Gell, "Vogel's Net: Traps as Artworks and Artworks as Traps," *Journal of Material Culture* 1, no. 1 (March 1996), pp. 15–38.

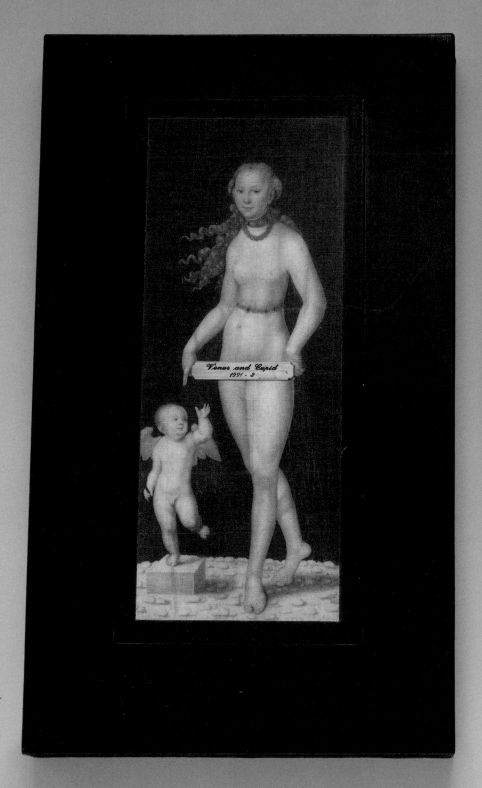

SONDRA SHERMAN
Venus and Cupid, 1991–93
Necklace in two parts with
fitted case
Necklace: gold, glass, and silver
Right: case; opposite, from left
to right: back of necklace, front

72

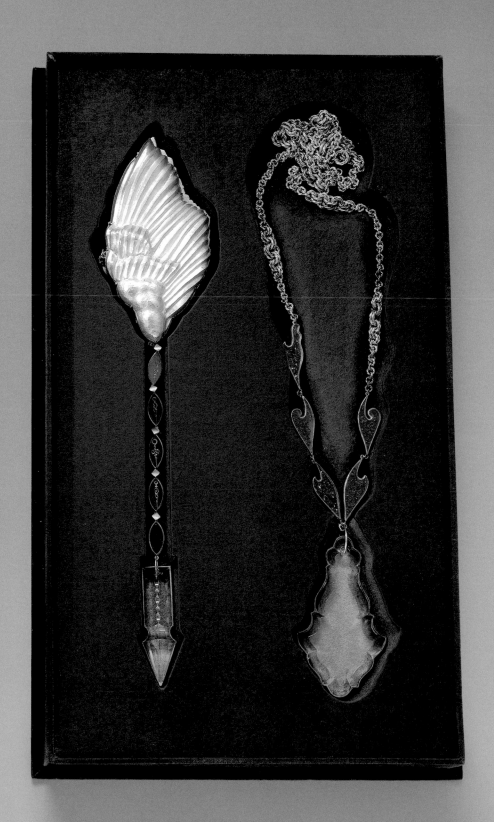

Fig. 10. Giovanni Corvaja (Italian, b. 1971). Brooch, 1999. 18K gold, 22K gold, and niello, 2½ × 2½ in. (6.4 × 6.4 cm). The Metropolitan Museum of Art, New York, Gift of Donna Schneier, 2007 (N.A.2007.134)

(now lost), a repurposed coatrack nailed to the floor, produced a physical and mental catch or stumbling block, intended to trip up the viewer. Likewise, much contemporary jewelry presents itself outright as optical traps. One primary structure of physical entrapment is the maze or labyrinth, built to disorient all those who enter. Bettina Dittlmann's brooch of about 2003 is like a miniaturized maze, crafted to ensnarl our eyes in its fretwork. Similar entanglements await the viewers of Giovanni Corvaja's gossamer-web brooch of 1999 (fig. 10) or the 2006 nestlike piece by Mari Ishikawa in the Schneier Collection.

At its finest, jewelry is a calculating snare; it arrests the eye and invites the mind to dwell. Extremely intricate things have this ability to immerse us in their complexity, leading to

BETTINA DITTLMANN
Brooch, ca. 2003
Iron, enamel, and garnet

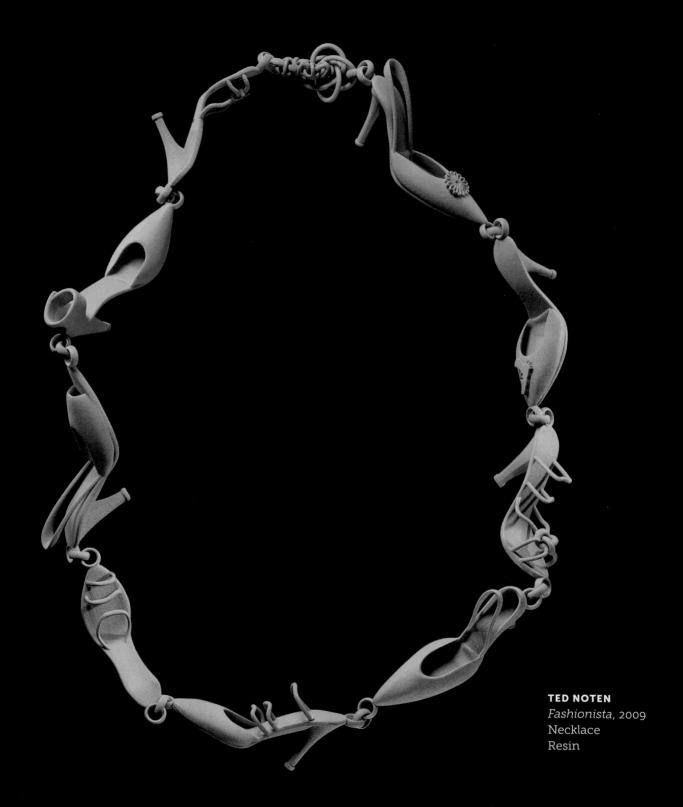

TED NOTEN
Fashionista, 2009
Necklace
Resin

PLATES

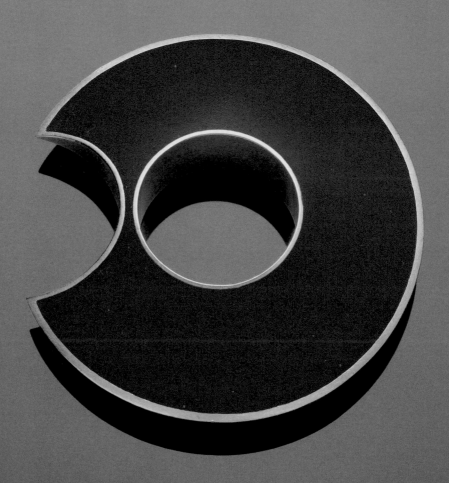

GIAMPAOLO BABETTO
*Anello da Mignolo (Ring for
Little Finger)*, 1983
Ring
18K gold and synthetic resin

82

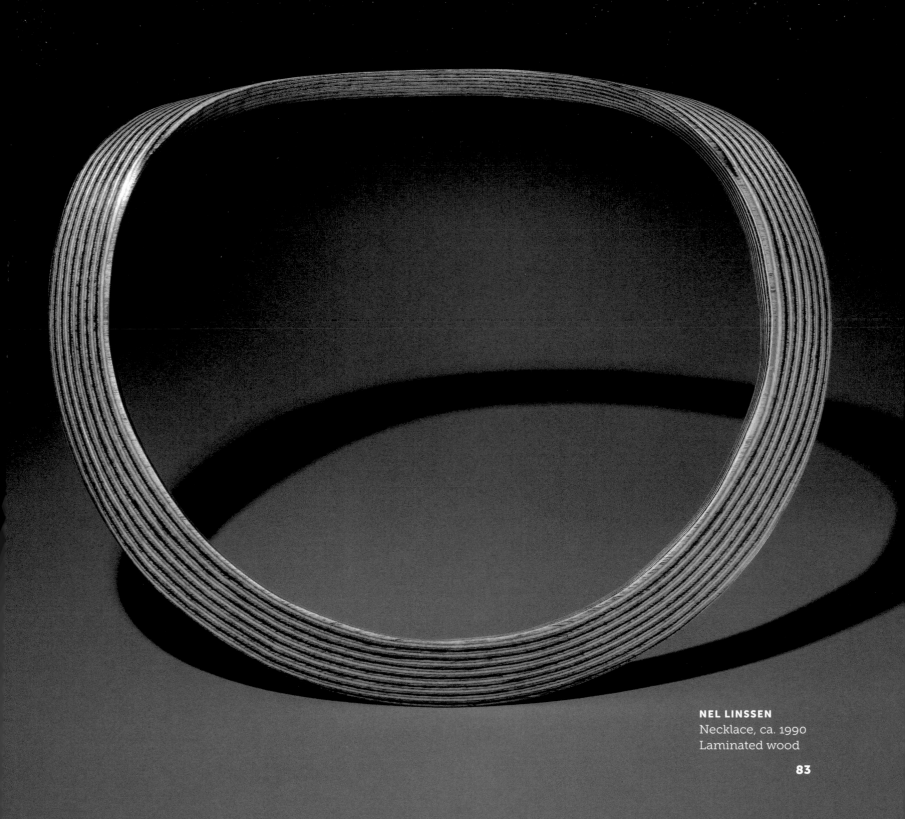

NEL LINSSEN
Necklace, ca. 1990
Laminated wood

83

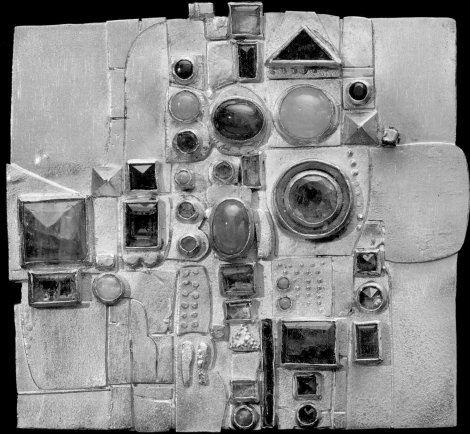

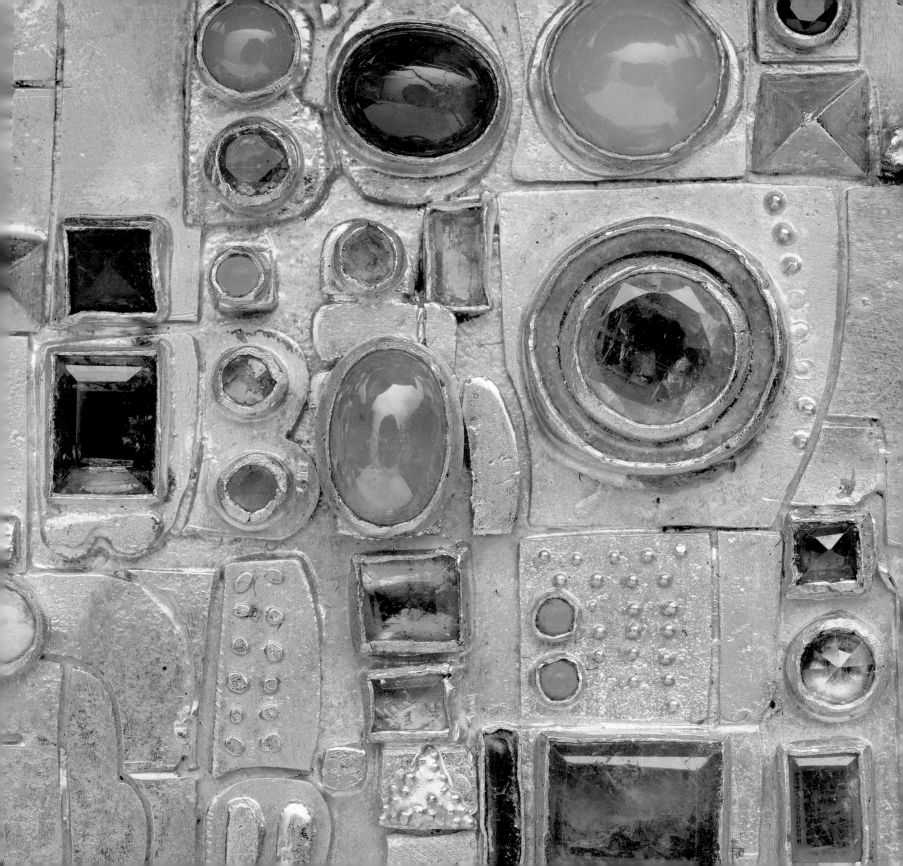

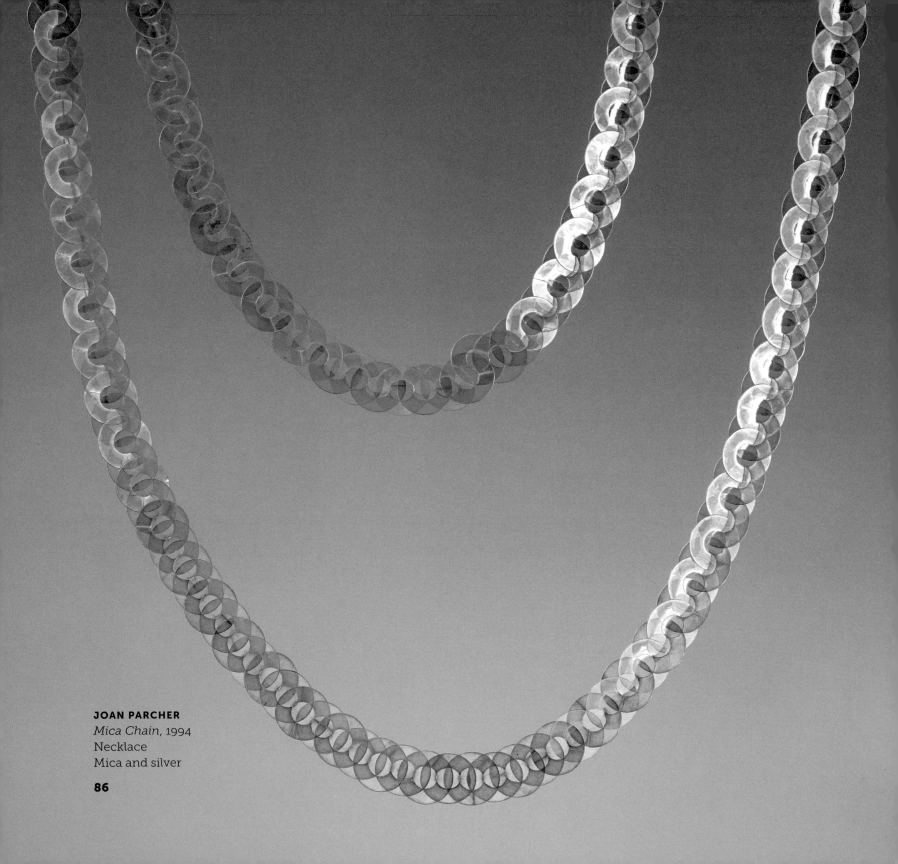

JOAN PARCHER
Mica Chain, 1994
Necklace
Mica and silver

86

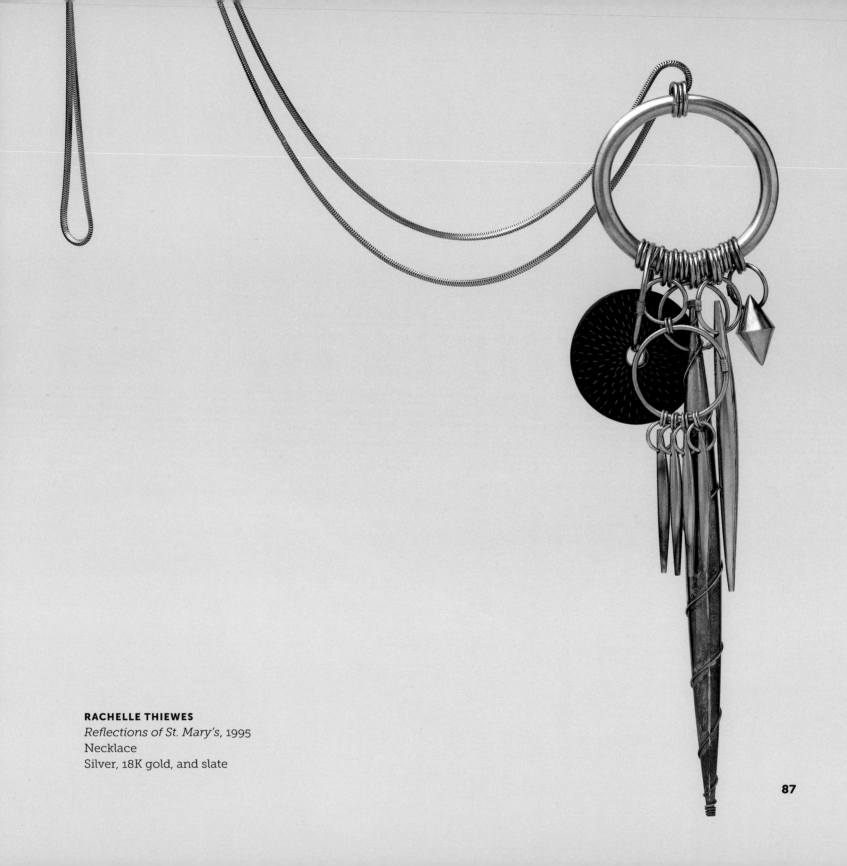

RACHELLE THIEWES
Reflections of St. Mary's, 1995
Necklace
Silver, 18K gold, and slate

87

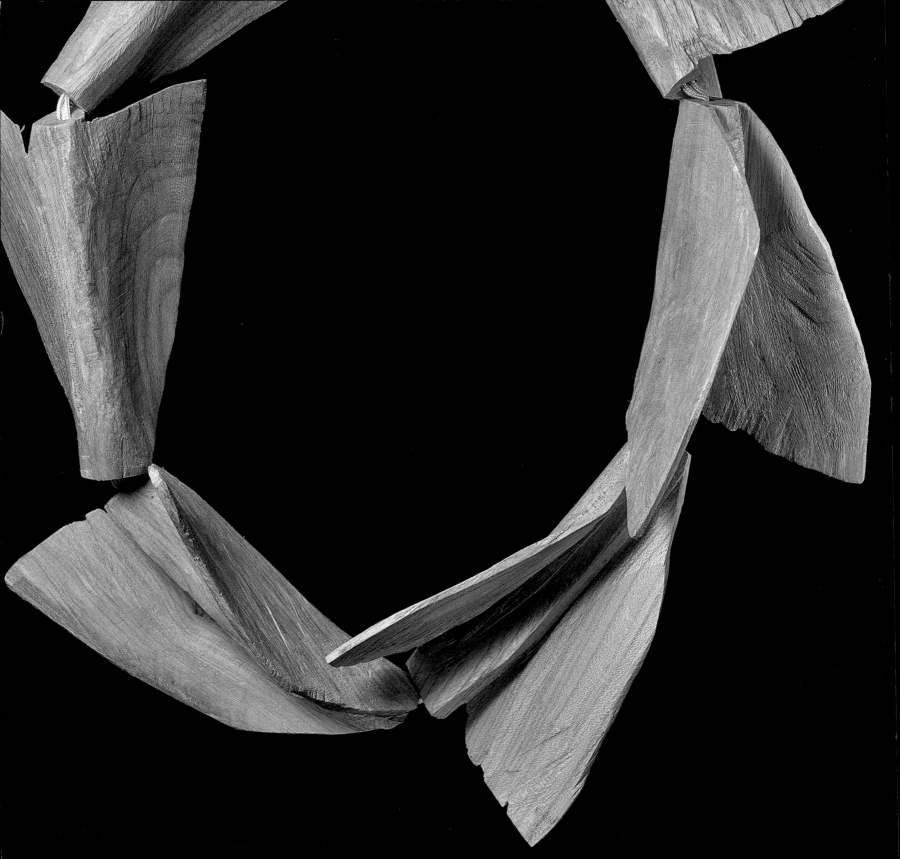

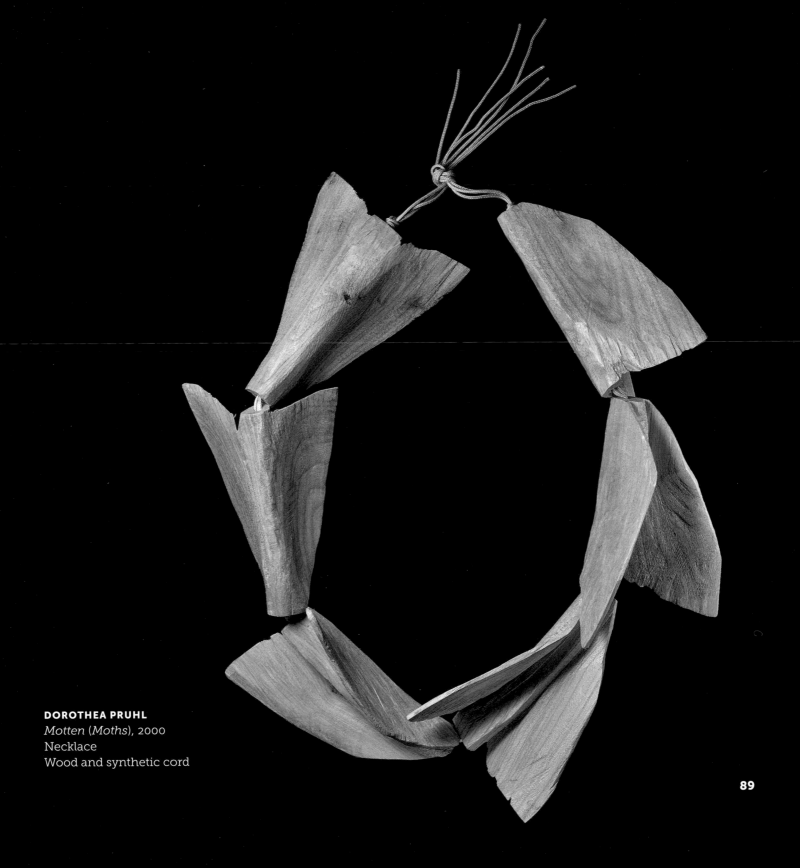

DOROTHEA PRUHL
Motten (*Moths*), 2000
Necklace
Wood and synthetic cord

89

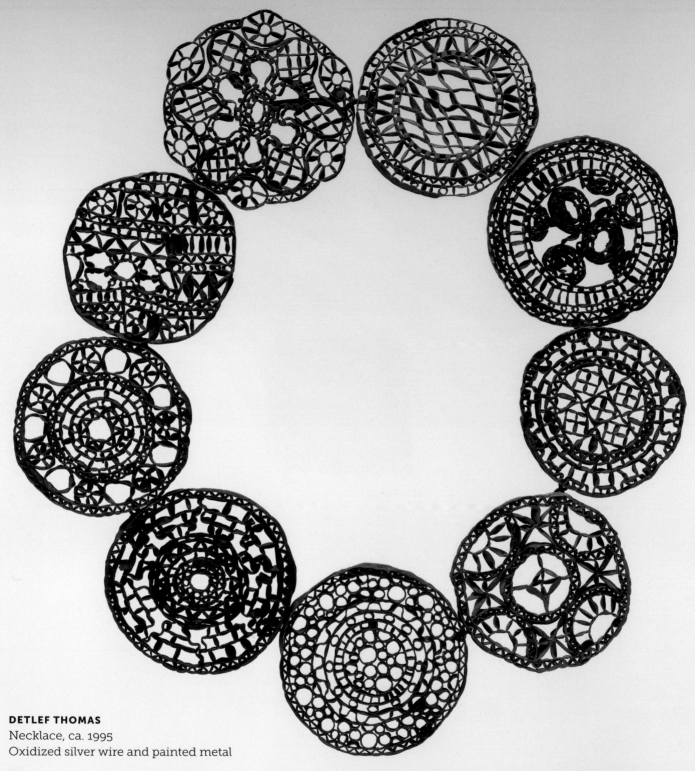

DETLEF THOMAS
Necklace, ca. 1995
Oxidized silver wire and painted metal

90

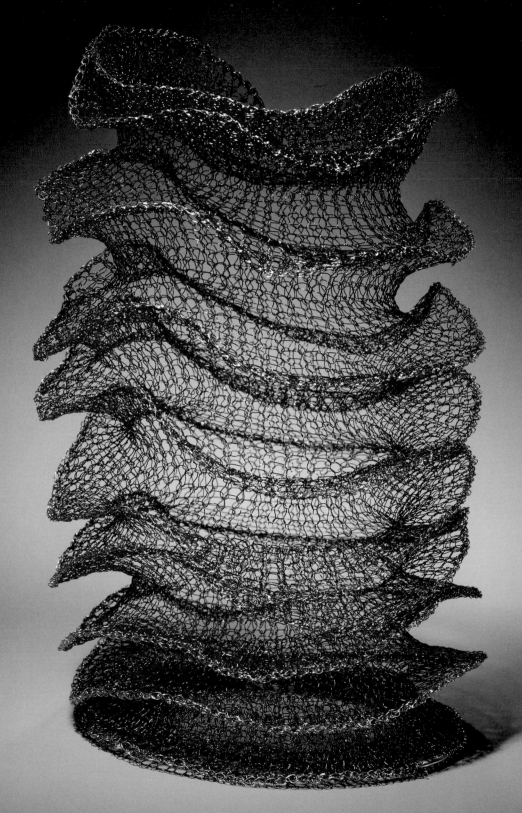

ARLINE FISCH
Bracelet, 2002
Coated copper wire
and silver wire

91

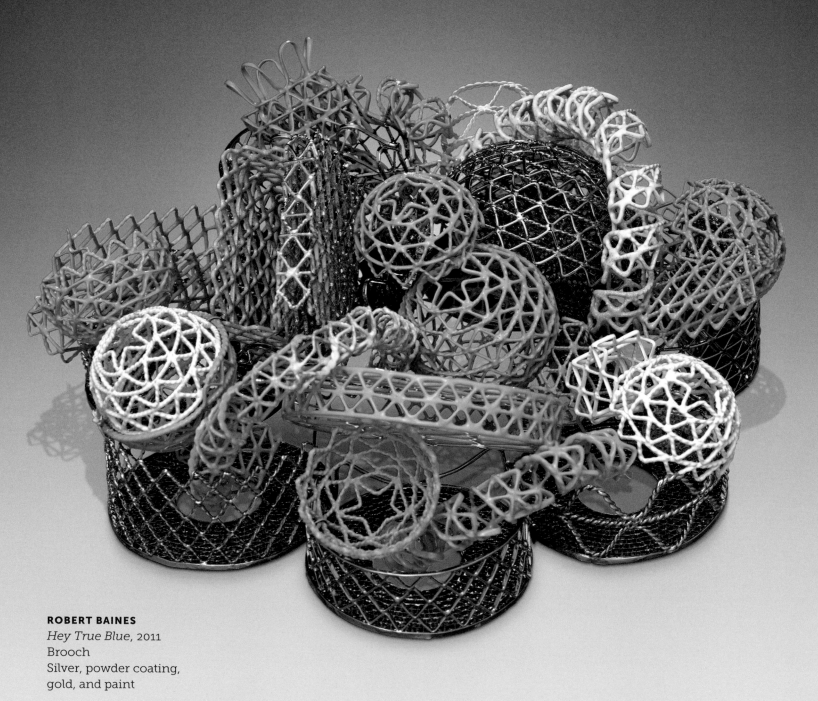

ROBERT BAINES
Hey True Blue, 2011
Brooch
Silver, powder coating,
gold, and paint

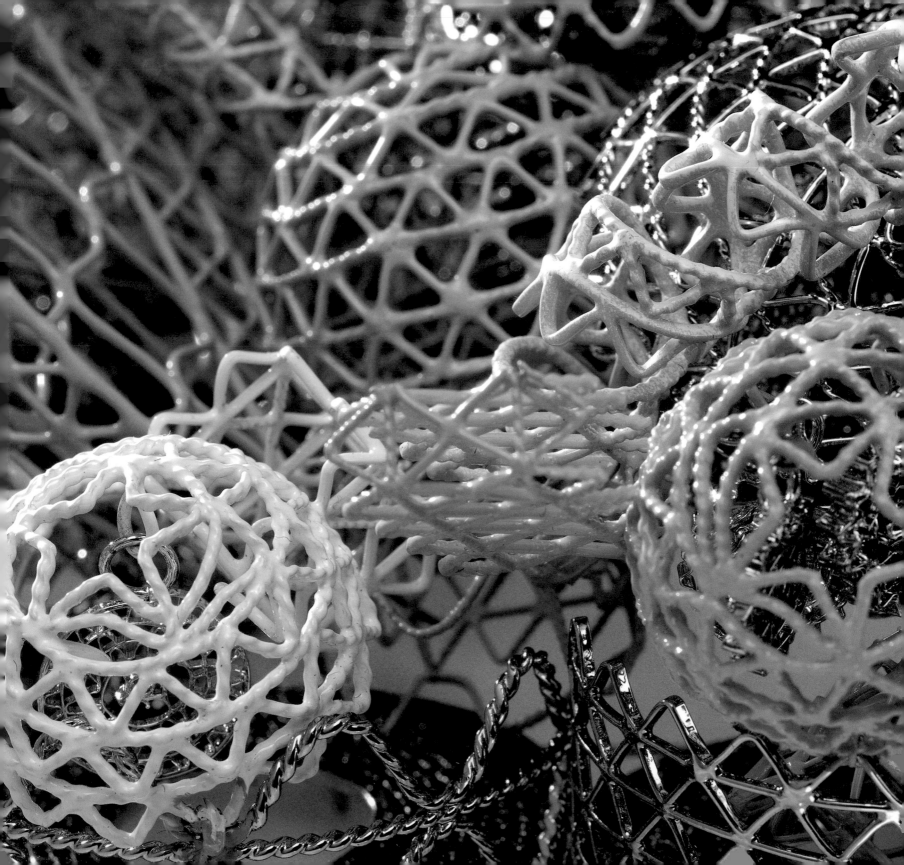

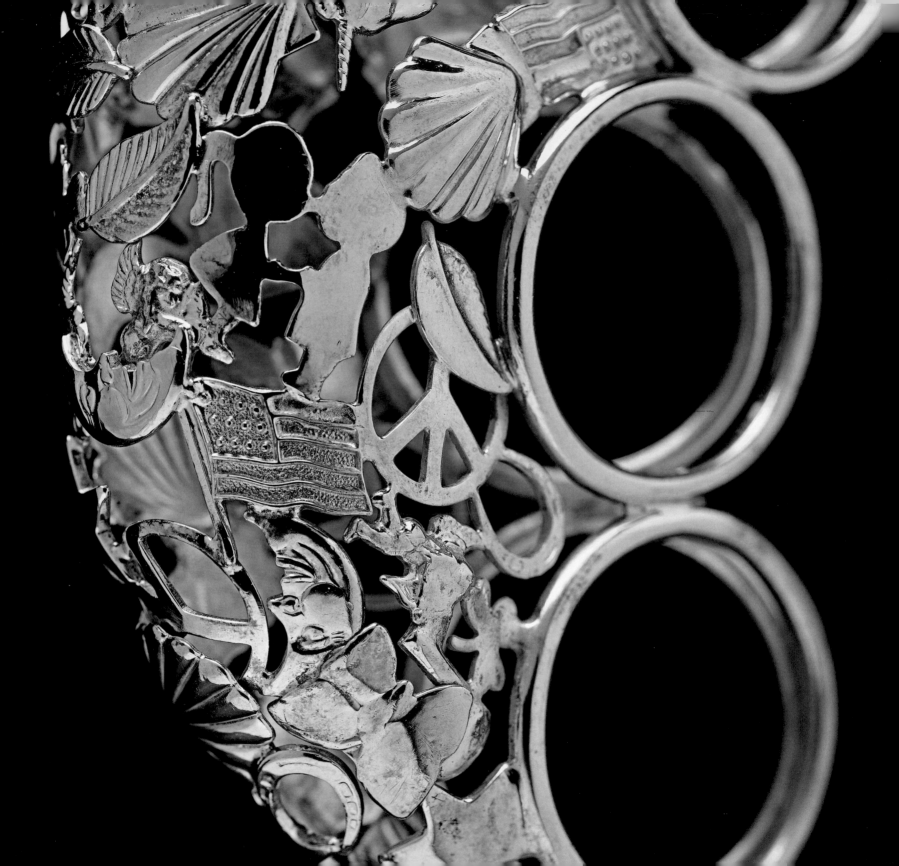

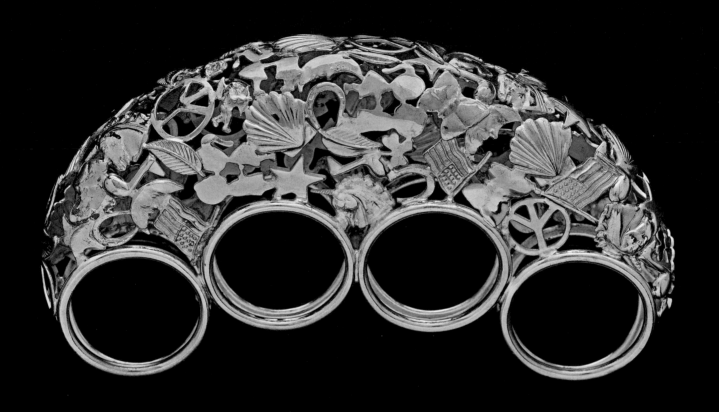

MYRA MIMLITSCH-GRAY
Brass Knuckles, 1993
24K gold over brass and brass charms

GEORG DOBLER
Brooch, 1987
Steel wire and black chrome

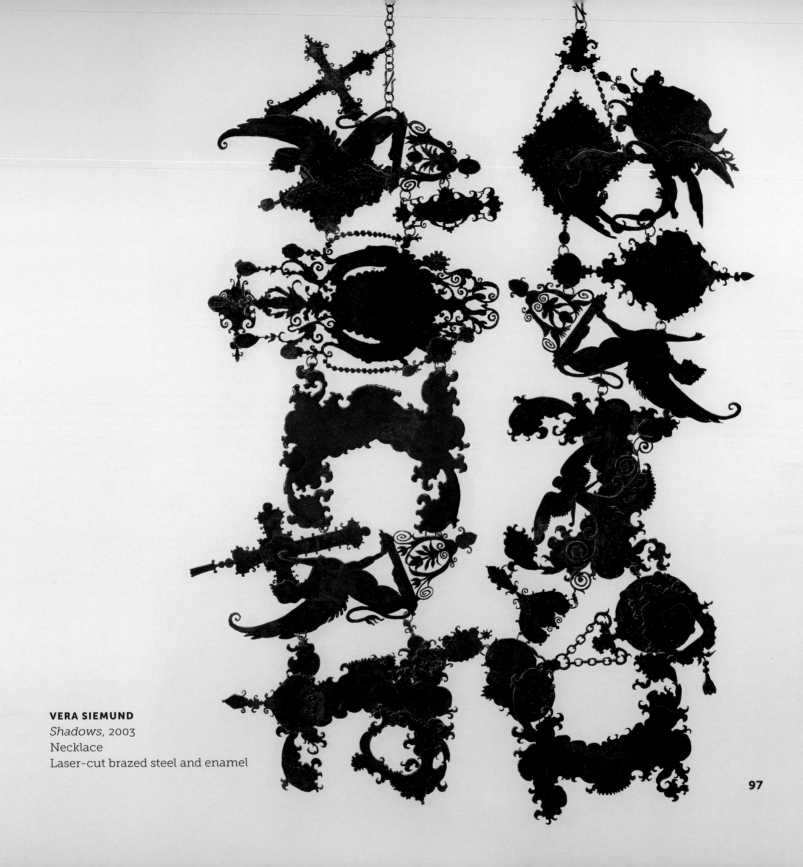

VERA SIEMUND
Shadows, 2003
Necklace
Laser-cut brazed steel and enamel

97

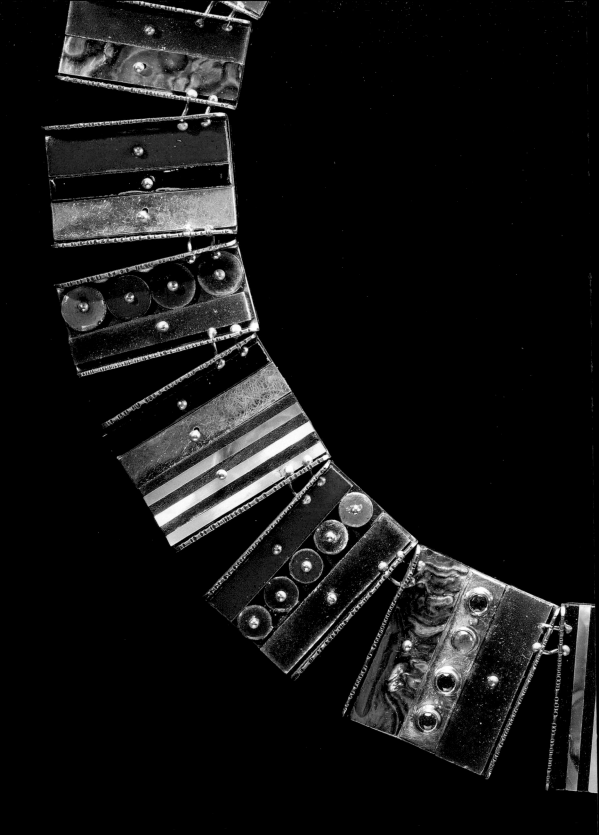

EARL PARDON
Necklace, 1989
Silver, 14K gold, 22K gold, enamel,
mother-of-pearl, ebony, and
semiprecious stones

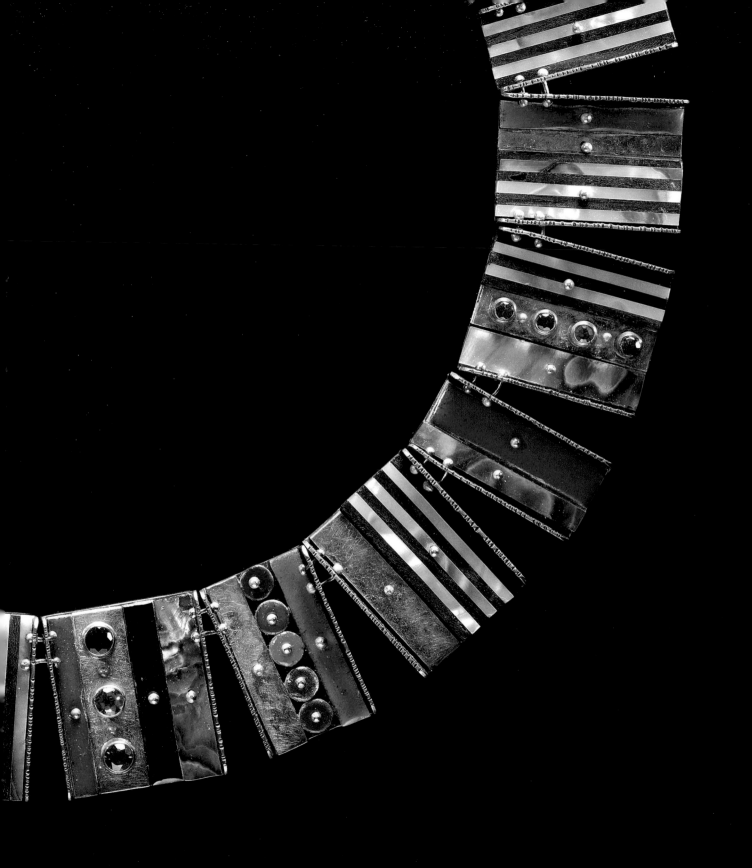

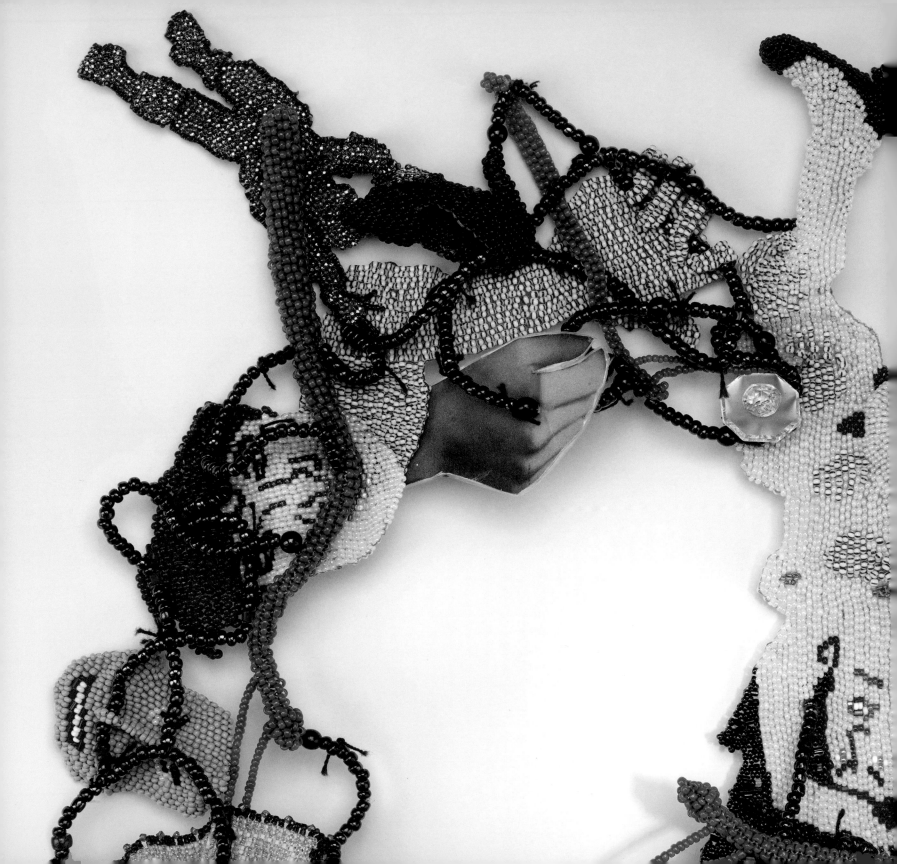

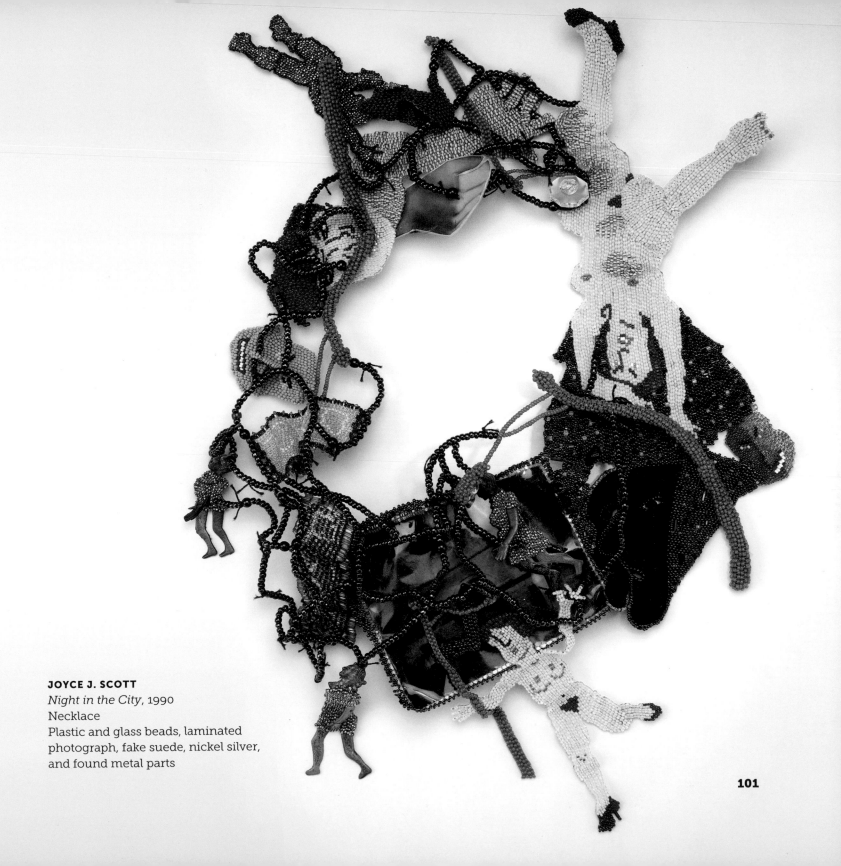

JOYCE J. SCOTT
Night in the City, 1990
Necklace
Plastic and glass beads, laminated
photograph, fake suede, nickel silver,
and found metal parts

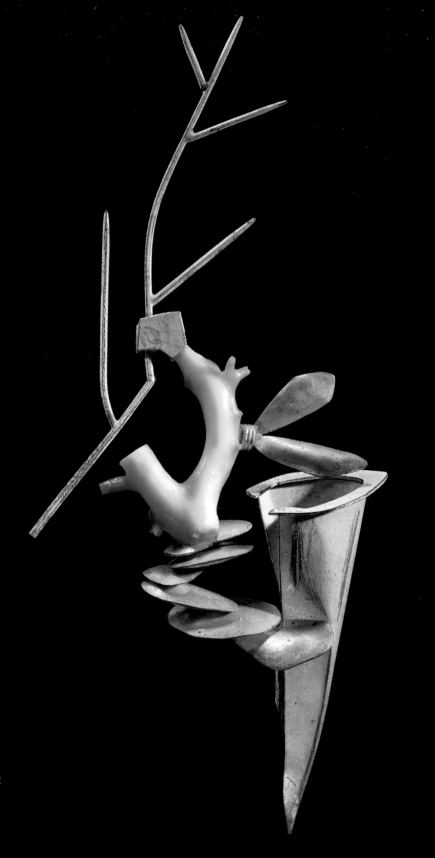

MANFRED BISCHOFF
Monte Fiascone, 1988
Brooch
Gold-plated silver and coral

RICHARD MAWDSLEY
Corsage #3, ca. 1990
Brooch
Silver, 18K-gold-plated tubing,
and pearls

103

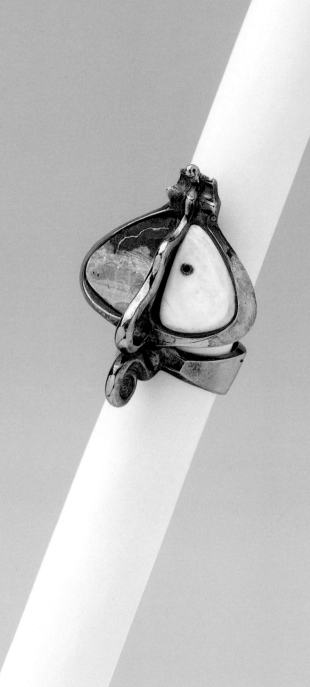

ALBERT PALEY
Ring, 1974
Opal, ivory, and 18K gold

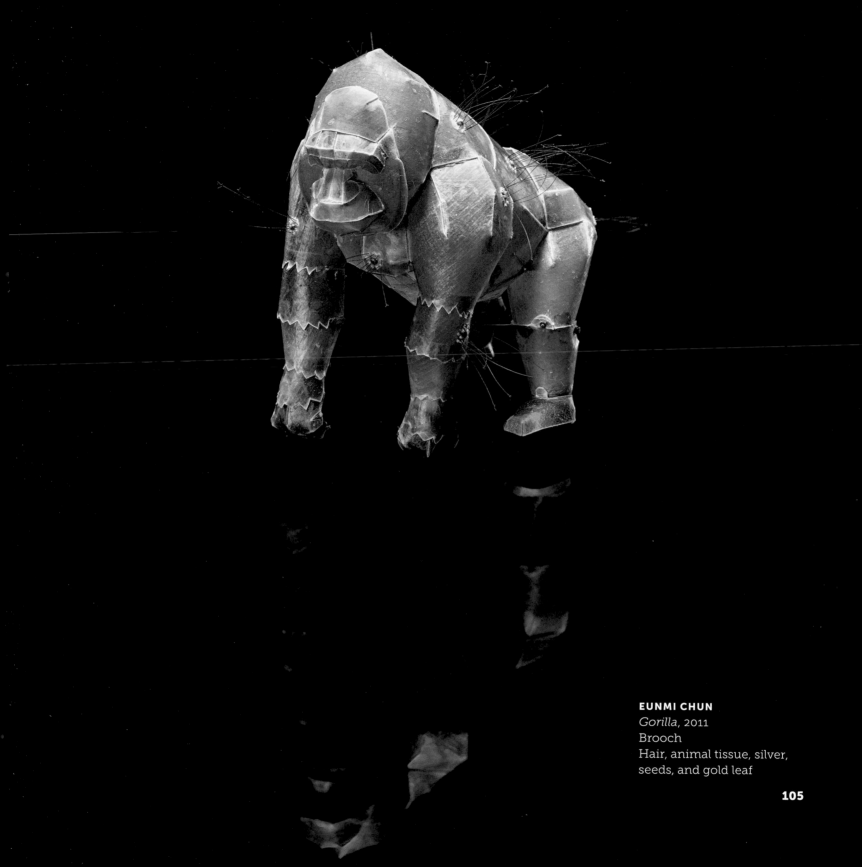

EUNMI CHUN
Gorilla, 2011
Brooch
Hair, animal tissue, silver,
seeds, and gold leaf

105

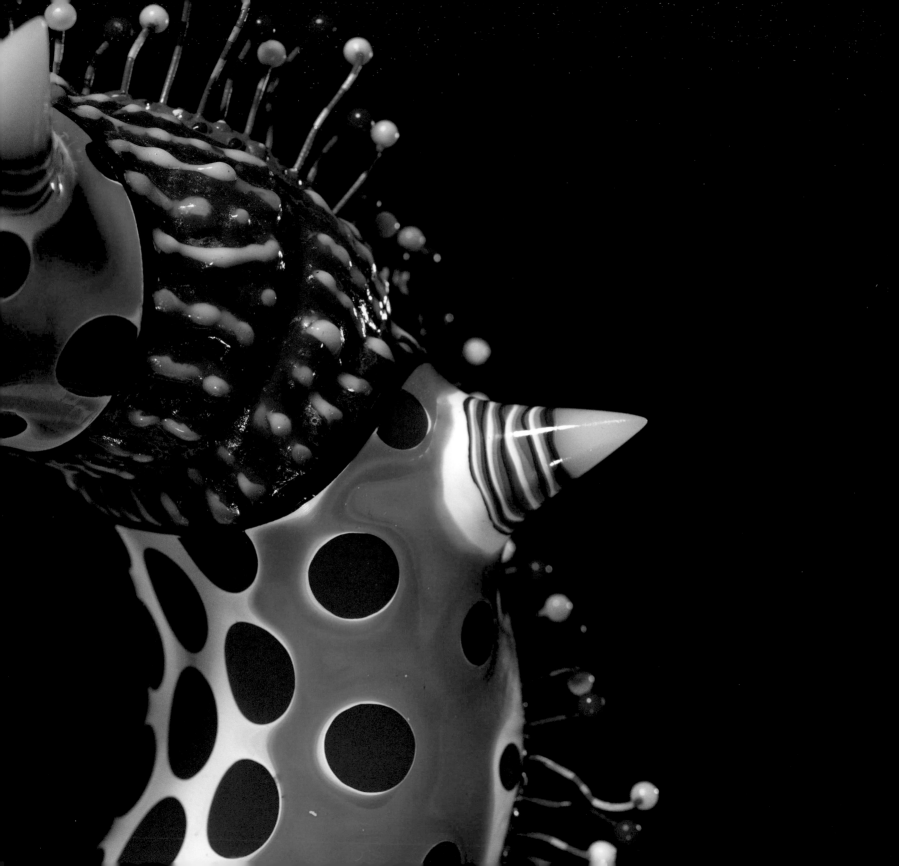

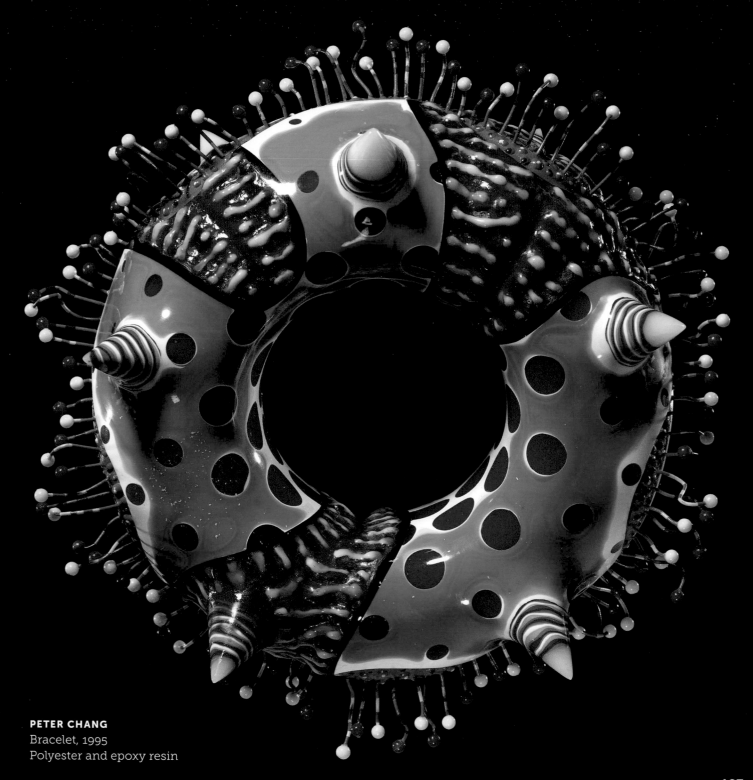

PETER CHANG
Bracelet, 1995
Polyester and epoxy resin

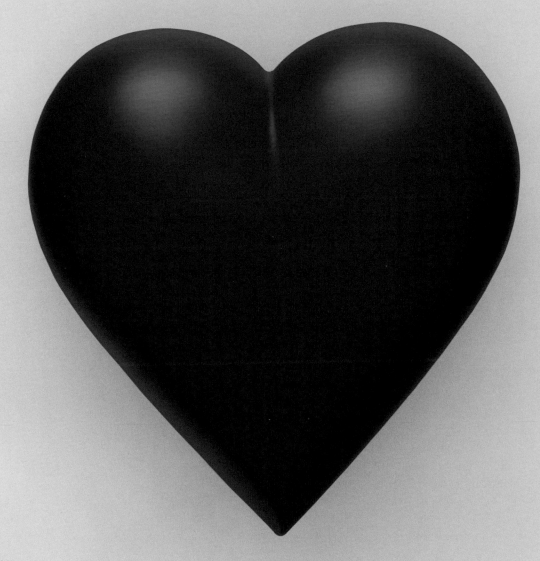

OTTO KÜNZLI
Heart, 1985
Brooch
Lacquer over Styrofoam

108

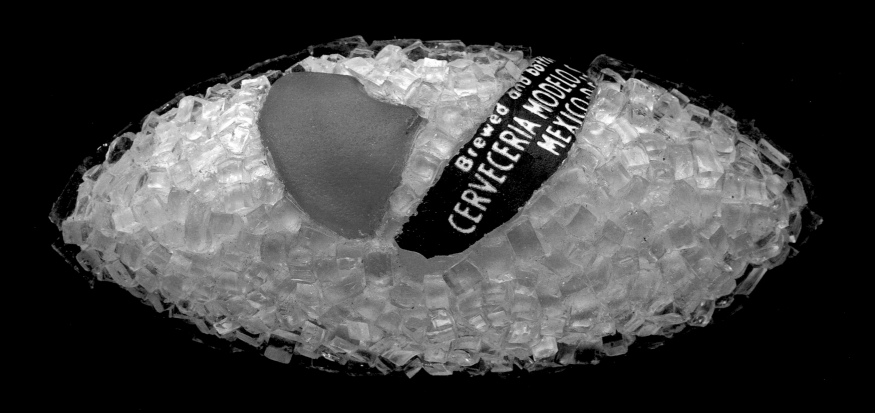

ROBERT EBENDORF
Brooch, 1991
Beach glass, automobile window
glass, and vinyl record

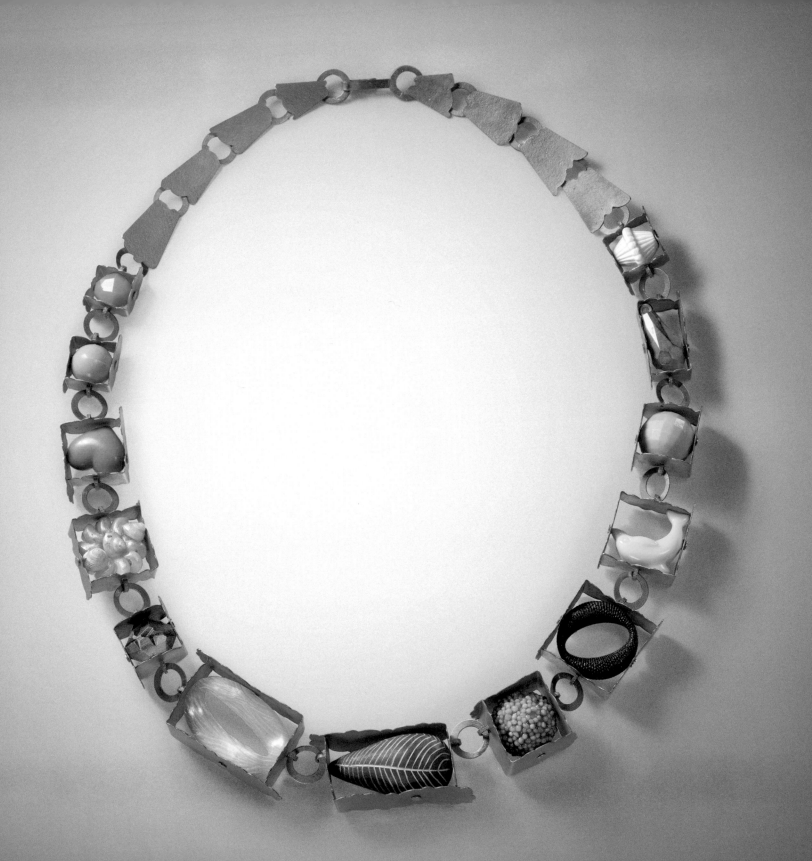

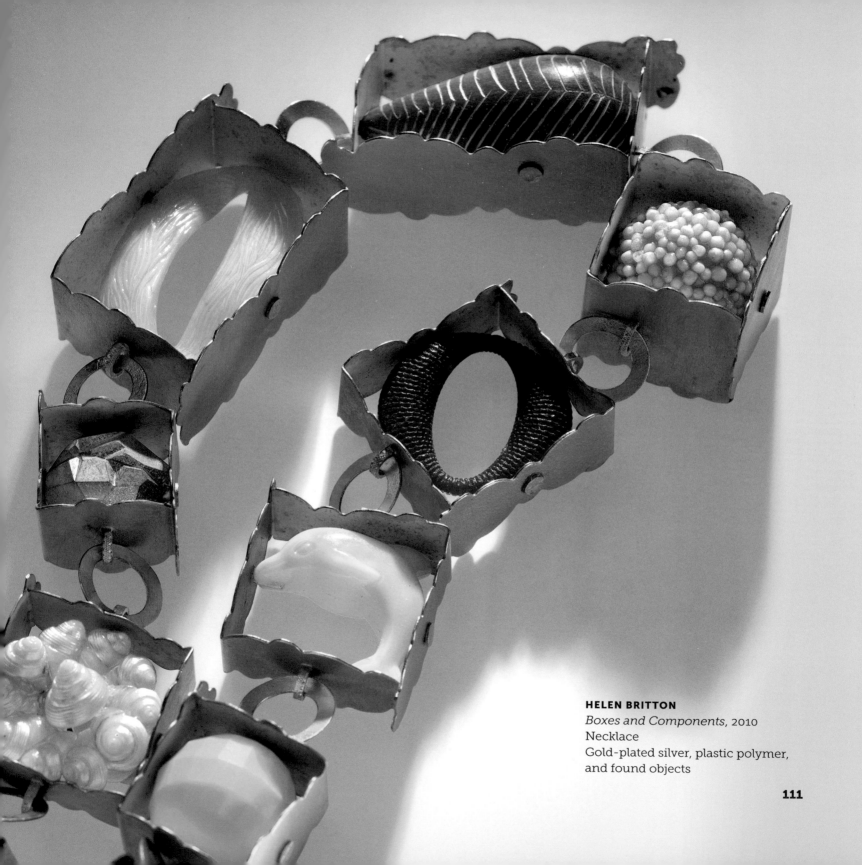

HELEN BRITTON
Boxes and Components, 2010
Necklace
Gold-plated silver, plastic polymer,
and found objects

111

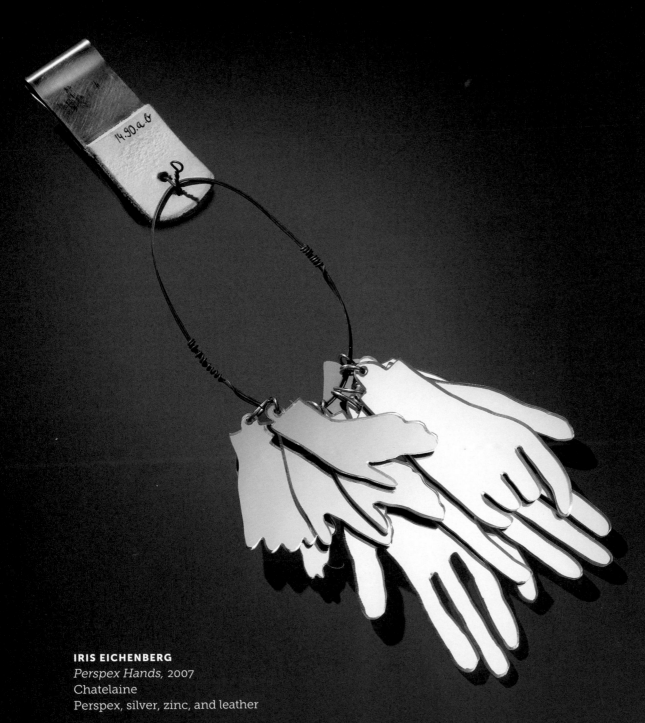

IRIS EICHENBERG
Perspex Hands, 2007
Chatelaine
Perspex, silver, zinc, and leather

112

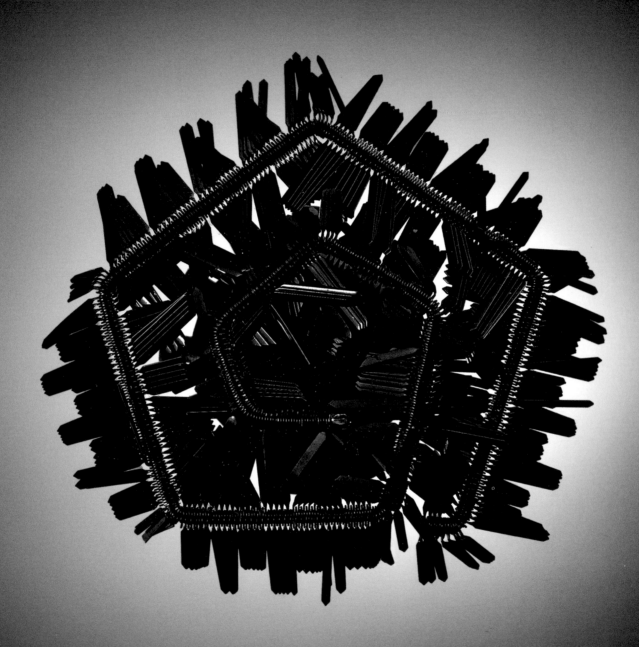

SERGEY JIVETIN
Brooch, 2006
Silver and watch hands

113

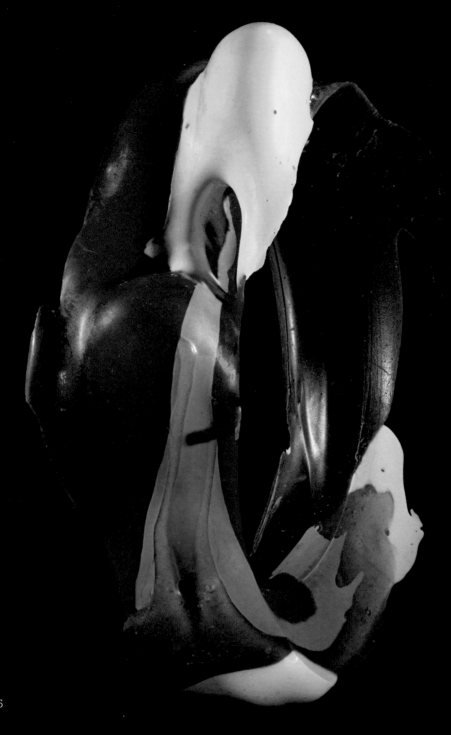

GAETANO PESCE
Bracelet, ca. 1995
Rubber

114

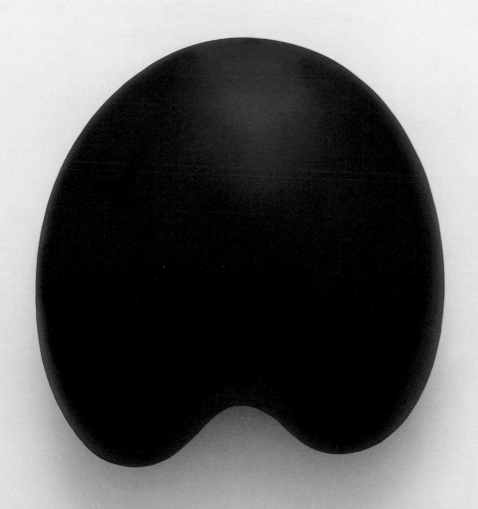

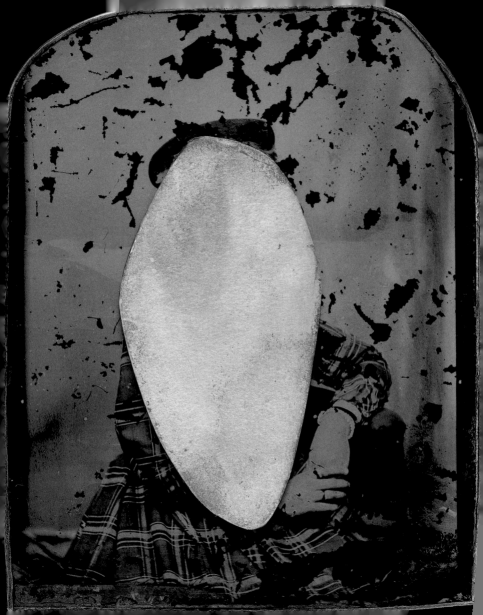

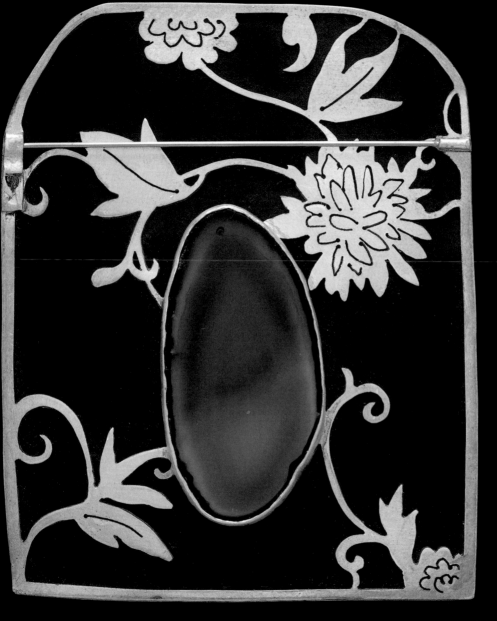

BETTINA SPECKNER
Brooch, 2000
Ferrotype, silver, and ag[
Back; opposite: front

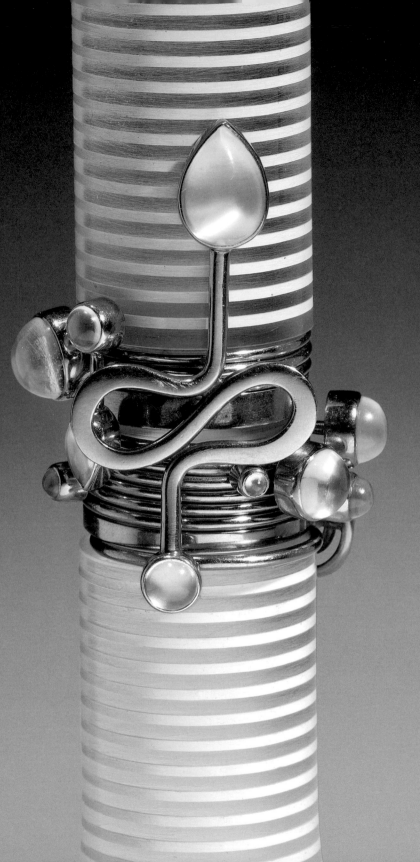

WENDY RAMSHAW
Rings and stand, 1992
Rings: 18K gold and moonstone
Stand: perspex

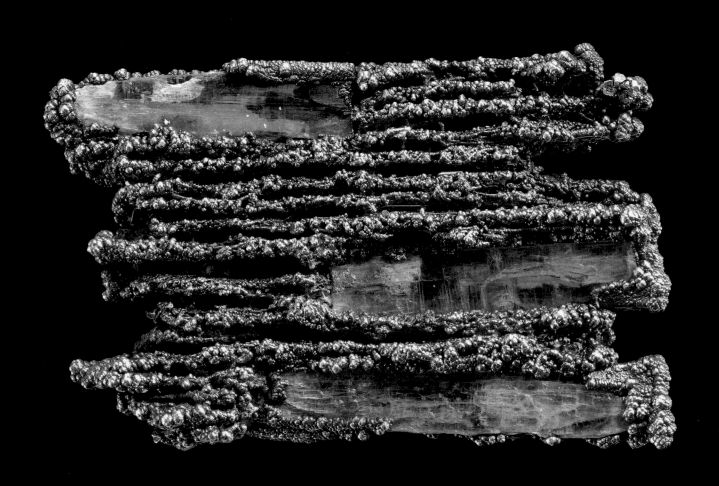

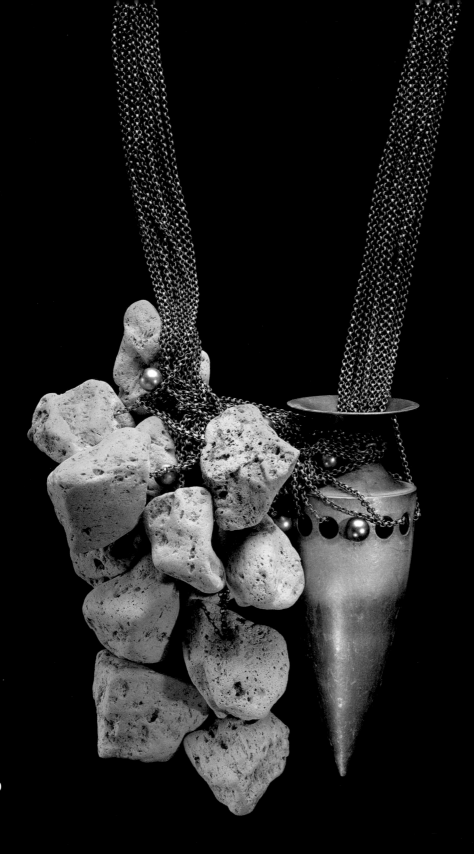

RUUDT PETERS
David, ca. 1995
Necklace
Silver, lava, and black pearls

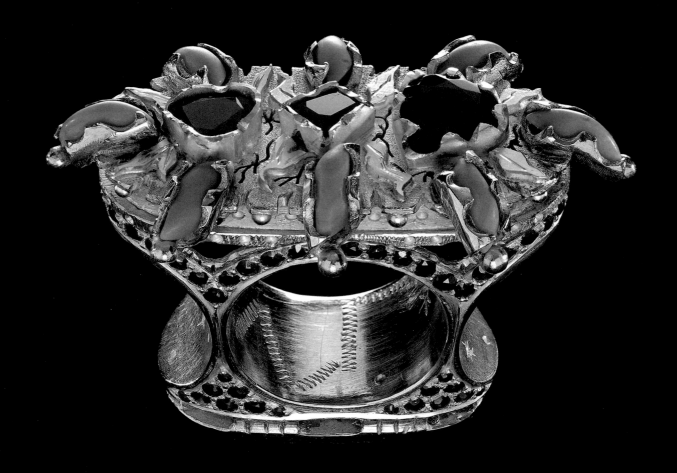

SABINE KLARNER
Ring, ca. 2000
Silver, coral, garnet, topaz,
carnelian, and gold

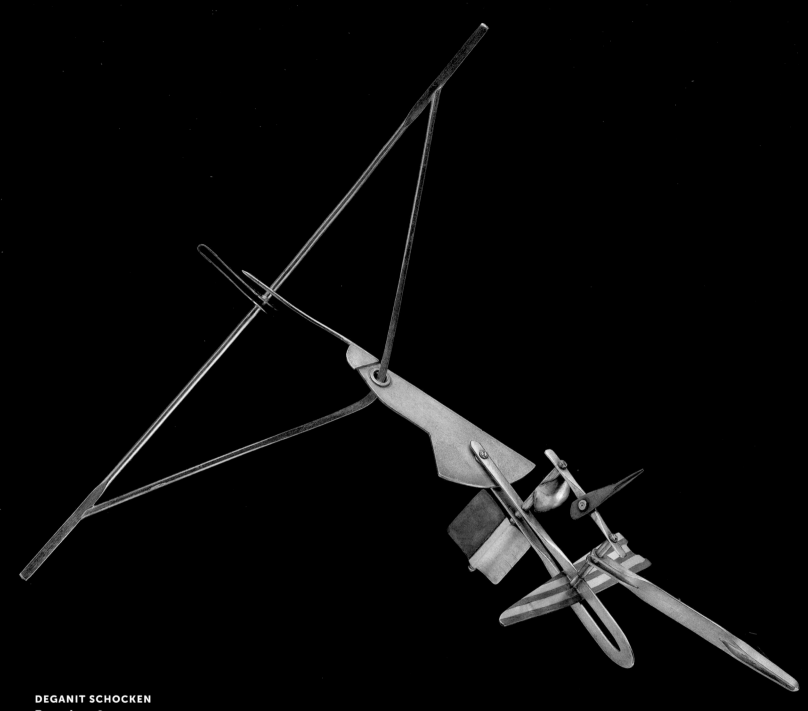

DEGANIT SCHOCKEN
Brooch, 1987
Copper and silver

122

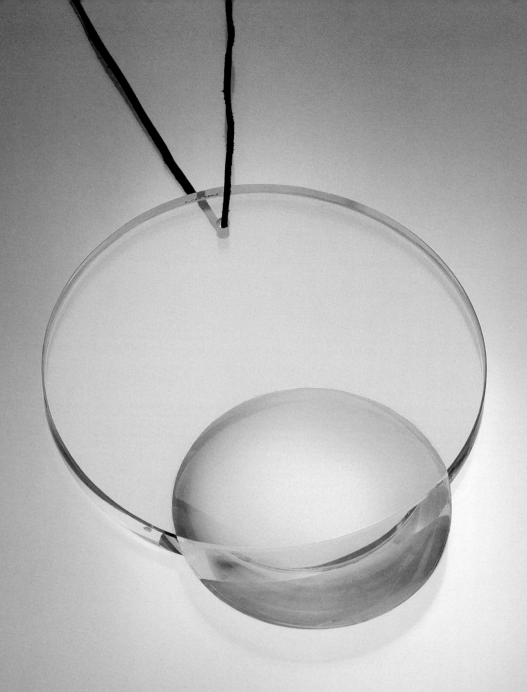

VÁCLAV CIGLER
Pendant, ca. 1960
Glass and leather

123

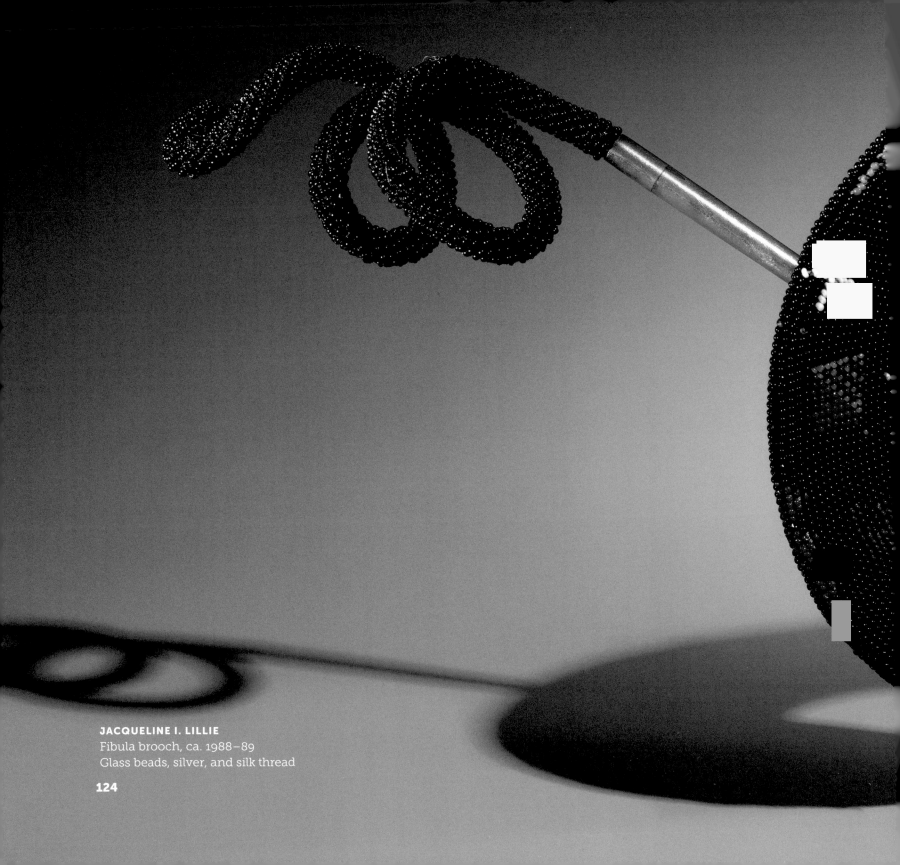

JACQUELINE I. LILLIE
Fibula brooch, ca. 1988–89
Glass beads, silver, and silk thread

124

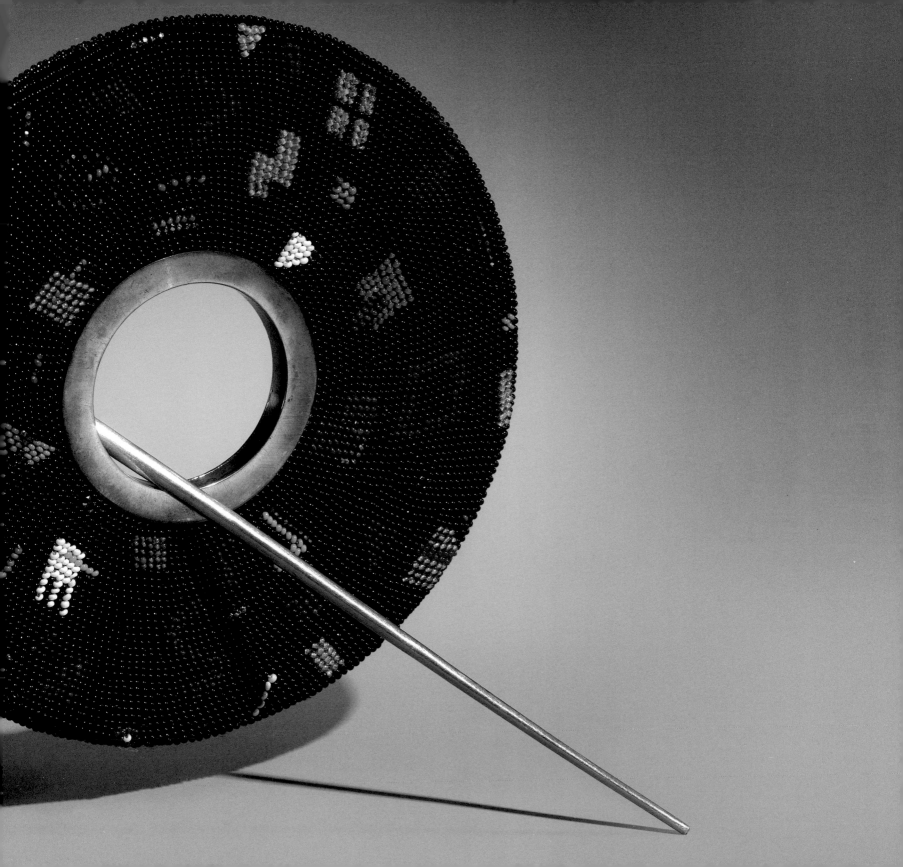

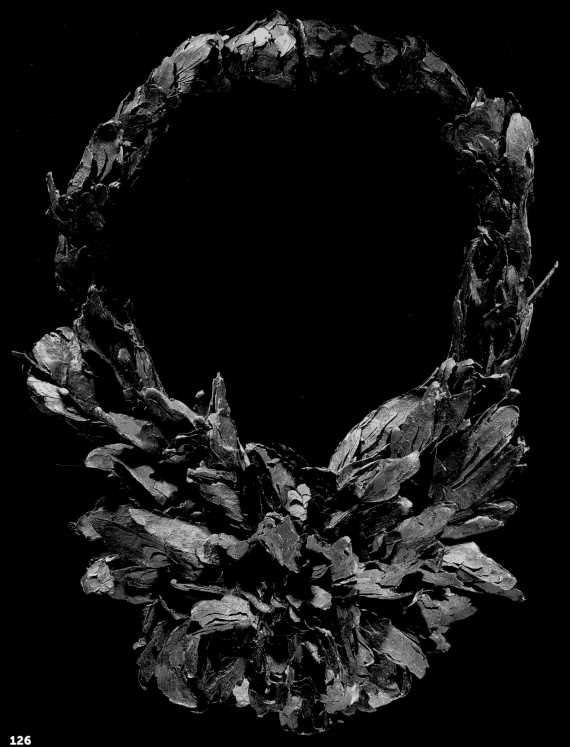

ATTAI CHEN
Necklace, 2011
Paper, paint, coal, glue,
and linen

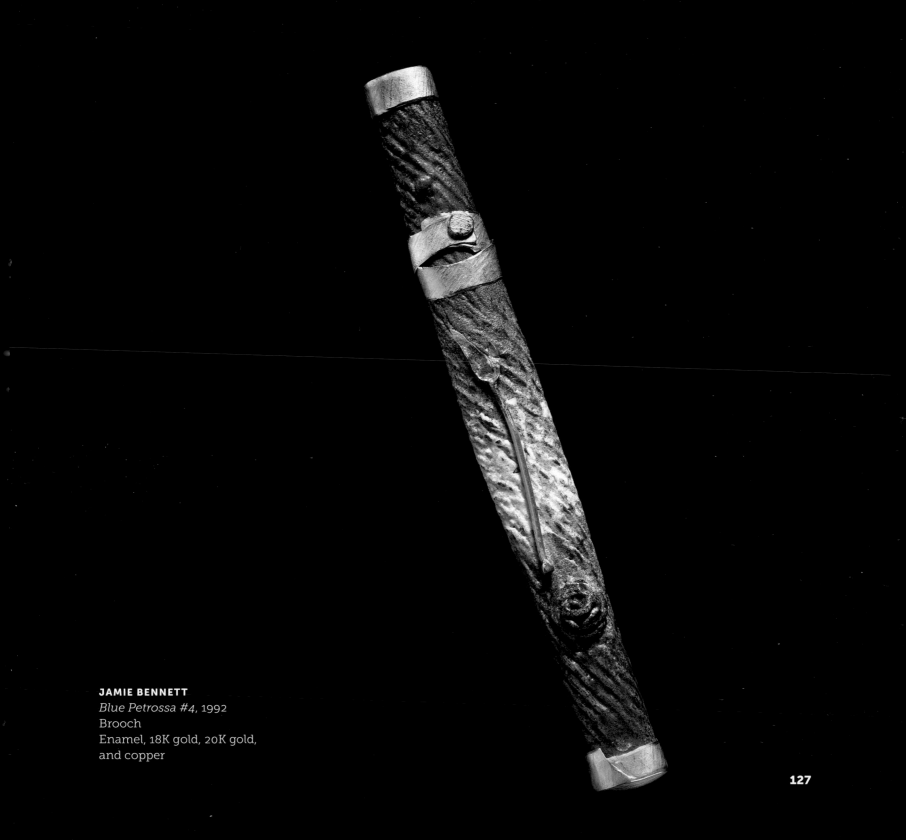

JAMIE BENNETT
Blue Petrossa #4, 1992
Brooch
Enamel, 18K gold, 20K gold,
and copper

127

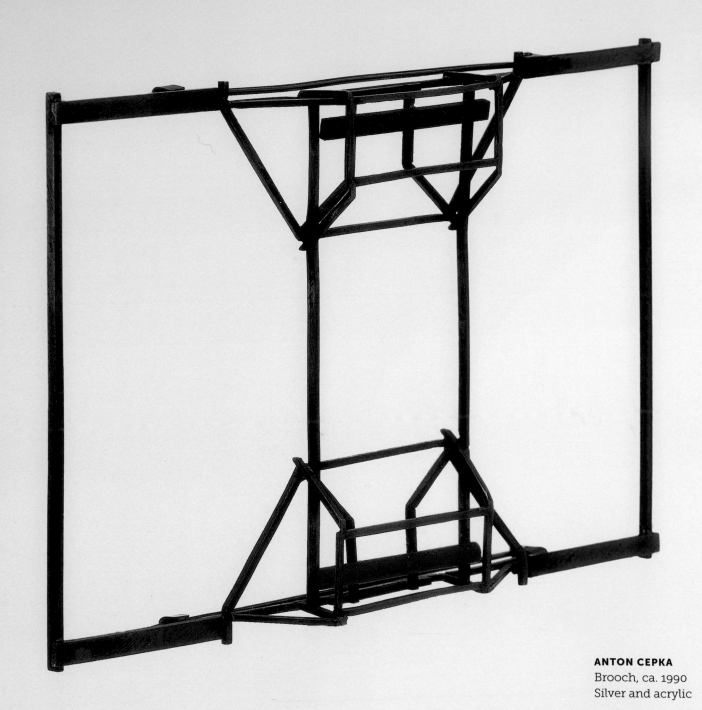

ANTON CEPKA
Brooch, ca. 1990
Silver and acrylic

LIST OF WORKS

Unless otherwise noted, all objects are Gift of Donna Schneier.

GIAMPAOLO BABETTO
Italian, born Padova 1947
Anello da Mignolo (*Ring for Little Finger*), 1983
Ring
18K gold and synthetic resin,
H. ½ × Diam. 1¾ in. (1.27 × 4.4 cm)
2007.384.1
Page 82

ROBERT BAINES
Australian, born Melbourne 1949
Hey True Blue, 2011
Brooch
Silver, powder coating, gold, and paint, D. 3¼ × Diam. 6½ in.
(8.3 × 16.5 cm); irreg.
2013.602.1
Pages 92–93

GIJS BAKKER
Dutch, born Amersfoort 1942
Diamond, 1991
Brooch
PVC-laminated photograph and diamond, H. 2⅞ × W. 4¼ in.
(7.3 × 10.8 cm)
2007.384.2a, b
Pages 28–29

JAMIE BENNETT
American, born Philadelphia 1948
Blue Petrossa #4, 1992
Brooch
Enamel, 18K gold, 20K gold, and copper, L. 5½ in. (14 cm)
2013.602.4
Page 127

MANFRED BISCHOFF
German, born Schömberg 1947
Monte Fiascone, 1988
Brooch
Gold-plated silver and coral, L. 5¾ × W. 2½ in. (14.6 × 6.4 cm); irreg.
2013.602.8
Jacket and page 102

ALEXANDER BLANK
German, born Büdingen 1975
Sylvester (Momentum Juniori) Childhood Memories, 2011
Necklace
Cast resin, silver, and cotton cord,
Pendant: H. 4½ × W. 3½ × D. 3¾ in. (11.4 × 8.9 × 9.5 cm)
Cord: L. 17½ in. (44.5 cm)
2013.602.9
Page 48

HELEN BRITTON
Australian, born Lithgow 1966
Boxes and Components, 2010
Necklace
Gold-plated silver, plastic polymer, and found objects, L. 20 in. (50.8 cm)
2013.602.5
Pages 110–11

LOLA BROOKS
American, born Ann Arbor 1969
Bloodgarnetheart, 2008
Brooch
Gold, silver, and garnet, H. 4 × W. 4½ in. (10.2 × 11.4 cm); D. irreg.
2013.602.3
Page 50

ANTON CEPKA
Slovakian, born Šulekovo 1936
Brooch, ca. 1990
Silver and acrylic, H. 2¼ × W. 3¼ × D. ½ in. (5.7 × 8.3 × 1.27 cm)
2007.384.5
Page 128

PETER CHANG
British, born London 1944
Bracelet, 1995
Polyester and epoxy resin, Diam. 7½ in. (19.1 cm); irreg.
2007.384.6
Pages 106–7

ATTAI CHEN
Israeli, born Jerusalem 1979
Necklace, 2011
Paper, paint, coal, glue, and linen,
L. 10½ × W. 7½ in. (26.7 × 19.1 cm);
D. irreg.
2013.602.7
Pages 14, 126

EUNMI CHUN
Korean, born Chungbuk 1971
Gorilla, 2011
Brooch
Hair, animal tissue, silver, seeds,
and gold leaf, H. 5¼ × W. 2¾ ×
D. 3¾ in. (13.3 × 7 × 9.5 cm)
2013.602.12
Page 105

VÁCLAV CIGLER
Czech, born Vsetín 1929
Pendant, ca. 1960
Glass and leather
Pendant: L. 5 × W. 4½ in.
(12.7 × 11.4 cm)
Thong: L. 32 in. (81.3 cm)
2007.384.7
Page 123

BETTINA DITTLMANN
German, born Passau 1964
Brooch, ca. 2003
Iron, enamel, and garnet, Diam.
4½ in. (11.4 cm); irreg.
N.A.2007.137
Pages 75, 136

GEORG DOBLER
German, born Creussen 1952
Brooch, 1987
Steel wire and black chrome,
H. 7½ × W. 3 × D. 1 in.
(19.1 × 7.6 × 2.5 cm)
2007.384.8
Page 96

ROBERT EBENDORF
American, born Topeka 1938
Brooch, 1991
Beach glass, automobile window
glass, and vinyl record, H. 2⅛ ×
W. 4⅞ × D. 1⅛ in. (5.4 × 12.4 × 2.9 cm)
N.A.2007.139
Page 109

IRIS EICHENBERG
German, born Göttingen 1965
Perspex Hands, 2007
Chatelaine
Perspex, silver, zinc, and leather,
H. 10⅛ × W. 3⅛ × D. ⅞ in.
(25.8 × 7.9 × 2.2 cm)
2007.384.9
Page 112

EVA EISLER
Czech, born Prague 1952
Mobius, 2002
Brooch
Stainless steel, H. 6 × W. 3¼ ×
D. 2¾ in. (15.2 × 8.3 × 7 cm)
2007.384.11
Page 57

ARLINE FISCH
American, born New York 1931
Bracelet, 2002
Coated copper wire and silver wire,
Diam. 5 in. (12.7 cm)
N.A.2007.142
Page 91

KARL FRITSCH
German, born Sonthofen 1963
Ring, 2005
Oxidized silver and rough
diamonds, H. 1½ × W. 1¾ × D. 1⅛ in.
(3.8 × 4.5 × 2.9 cm)
2007.384.12
Page 33

FUKUCHI KYOKO
Japanese, born Hiroshima 1946
Brooch, ca. 2002
Japanese lacquer, H. 2½ × W. 2¼ in.
(6.4 × 5.7 cm)
N.A.2007.143
Page 115

THOMAS GENTILLE
American, born Mansfield, Ohio 1936
Bracelet, 1988–2008
Ebony, eggshell, jet, and pigment,
D. 1⅞ × Diam. 4¾ in. (4.8 × 12.1 cm)
2013.602.2
Page 56

WILLIAM HARPER
American, born Bucyrus, Ohio 1944
*Homage to Cy Twombly and Joseph
Cornell*, ca. 1994
Brooch with book
Brooch: gold cloisonné enamel on
silver and gold; 14K gold, 18K gold,
and 24K gold; silver; coral; opal;
pearl; tourmaline; and agate,
H. 6½ × W. 5¼ × D. ½ in. (16.5 ×
13.3 × 1.27 cm); irreg.
Book: leather and mixed media,
H. 15 × W. 13 × D. 4 in. (38.1 × 33 ×
10.2 cm)
2007.384.18a, b
Pages 2–3, 54–55

HIRAMATSU YASUKI
Japanese, Osaka 1926–2012 Osaka
Brooch, ca. 1976
Gold, Diam. 2¾ in. (7 cm); irreg.
N.A.2007.150
Page 36

MARY LEE HU
American, born Lakewood, Ohio 1943
Choker #70, 1985
Necklace
18K gold and 22K gold, H. 8¼ ×
W. 10½ × D. 1½ in. (21 × 26.7 × 3.8 cm)
2007.384.22
Pages 34–35

SERGEY JIVETIN
Uzbekistani, born Tashkent 1977
Brooch, 2006
Silver and watch hands, H. 2¼ ×
W. 2¼ in. (5.7 × 5.7 cm); D. irreg.
N.A.2007.153
Page 113

DANIEL JOCZ
American, born Beloit, Wisconsin
1943
Postcard from Tuscany, 1995
Brooch with frame
Brooch: silver and acrylic paint,
H. 2¾ × W. 3¼ × D. 1¼ in.
(7 × 8.3 × 3.2 cm)
Frame: gilded wood, H. 7⅞ ×
W. 8½ in. (20 × 21.6 cm)
N.A.2007.154a, b
Pages 46–47

HERMANN JÜNGER
German, Hanau 1928–2005 Pöring
Brooch, ca. 1970–72
18K gold, emeralds, chrysoprase,
sapphires, opals, lapis lazuli, and
enamel, H. 2 × W. 1⅞ in. (5.1 × 4.8 cm)
2007.384.27
Jacket and pages 84–85

SABINE KLARNER
German, born Istanbul, Turkey 1957
Ring, ca. 2000
Silver, coral, garnet, topaz, carnelian,
and gold, H. 1⅜ × W. 2⅛ × D. 1⅛ in.
(3.5 × 5.4 × 2.9 cm)
2007.384.28
Page 121

ROBIN KRANITZKY
American, born Christiansburg,
Virginia 1956
KIM OVERSTREET
American, born Richmond 1955
Ambiguity, 2005
Brooch
Eggshell, brass, Micarta, string,
copper, glass bead, flocking,
postcard fragments, insect wings,
celluloid, and found objects,
H. 2½ × W. 3 × D. 1 in.
(6.4 × 7.6 × 2.5 cm); irreg.
N.A.2007.158
Page 51

ALYSSA DEE KRAUSS
American, born Hempstead,
New York 1962
I Sing the Body Electric, 1998
Necklace
Silver, L. 39 in. (99.1 cm)
N.A.2007.159
Pages 64–65

OTTO KÜNZLI
Swiss, born Zurich 1948
Heart, 1985
Brooch
Lacquer over Styrofoam,
H. 4 × W. 2¾ × D. 2⅛ in.
(10.2 × 7 × 5.4 cm)
2007.384.29
Page 108

STANLEY LECHTZIN
American, born Detroit 1936
Brooch, ca. 1966
Silver and tourmaline, H. 1¾ ×
W. 2½ in. (4.4 × 6.4 cm); D. irreg.
2007.384.31
Page 119

KEITH LEWIS
American, born Bellefonte,
Pennsylvania 1959
Bloom, 1998
Necklace
Silver, gold leaf, and enamel,
Pendant: H. 3 × W. 1¾ × D. 1¾ in.
(7.6 × 4.5 × 4.5 cm)
Chain: L. 13¼ in. (33.7 cm)
2007.384.32
Pages 42–43

JACQUELINE I. LILLIE
French, born Marseille 1941
Fibula brooch, ca. 1988–89
Glass beads, silver, and silk thread
Rondel: Diam. 4¾ in. (12.1 cm)
Fibula: L. 8 in. (20.3 cm)
2007.384.33a, b
Pages 124–25

NEL LINSSEN
Dutch, born Mook en Middelaar 1935
Necklace, ca. 1990
Laminated wood, Diam. 9½ in.
(24.1 cm)
N.A.2007.164
Page 83

BRUNO MARTINAZZI
Italian, born Turin 1923
Eco, 1992
Ring
20K gold and white gold, H. 1¼ ×
W. 1⅛ × D. 1¼ in. (3.2 × 2.9 × 3.2 cm)
2007.384.35
Page 17

RICHARD MAWDSLEY
American, born Winfield, Kansas
1945
Corsage #3, ca. 1990
Brooch
Silver, 18K-gold-plated tubing, and
pearls, H. 5 × W. 2¼ in. (12.7 × 5.7 cm);
D. irreg.
2007.384.36
Page 103

BRUCE METCALF
American, born Amherst 1949
Memento Mori, 2001
Brooch with stand
Brooch: boxwood, diamonds, 18K
gold, and cotton thread, H. 4 ×
W. 1⅛ × D. 1 in. (10.2 × 2.9 × 2.5 cm)
Stand: painted basswood, H. 13 ×
W. 5⅛ × D. 2¾ in. (33 × 13 × 7 cm)
2007.384.37a, b
Pages 44–45

MYRA MIMLITSCH-GRAY
American, born Camden,
New Jersey 1962
Brass Knuckles, 1993
24K gold over brass and brass
charms, H. 2¼ × W. 4 × D. 1 in.
(5.7 × 10.2 × 2.5 cm)
2007.384.38
Pages 94–95

TED NOTEN
Dutch, born Tegelen 1956
Fashionista, 2009
Necklace
Resin, L. 40 in. (101.6 cm)
2013.602.6
Pages 80–81

PAVEL OPOCENSKÝ
Czech, born Karlovy Vary 1954
Art, ca. 1988–89
Brooch
Carved wood skis, H. 2¼ × W. 2½ ×
D. ⅝ in. (5.7 × 6.4 × 1.59 cm)
2007.384.41
Pages 6, 58

BARBARA PAGANIN
Italian, born Venice 1961
Kinetic, 1998
Brooch
Opal and lapis lazuli beads and
18K gold wire on silver, Diam. 2½ in.
(6.4 cm); D. irreg.
N.A.2007.170
Page 66

ALBERT PALEY
American, born Philadelphia 1944
Ring, 1974
Opal, ivory, and 18K gold, H. 1⅜ ×
W. 1¼ × D. 1⅝ in. (3.2 × 3.3 × 4.1 cm)
2007.384.42
Page 104

JOAN PARCHER
American, born Pittsburgh 1956
Mica Chain, 1994
Necklace
Mica and silver, L. 35 in. (88.9 cm)
N.A.2007.171
Page 86

EARL PARDON
American, Memphis 1926–1991
Boston
Necklace, 1989
Silver, 14K gold, 22K gold, enamel,
mother-of-pearl, ebony, and
semiprecious stones, L. 16 × W. 1 in.
(40.6 × 2.5 cm)
2007.384.44
Pages 98–99

GAETANO PESCE
Italian, born La Spezia 1939
Bracelet, ca. 1995
Rubber, Diam. 4½ in. (11.4 cm); irreg.
N.A.2007.172
Page 114

RUUDT PETERS
Dutch, born Naaldwijk 1950
David, ca. 1995
Necklace
Silver, lava, and black pearls,
H. 16 × W. 4 × D. 2⅞ in.
(40.6 × 10.2 × 7.3 cm)
N.A.2007.174
Page 120

EUGENE PIJANOWSKI
American, born Detroit 1938
HIROKO PIJANOWSKI
Japanese, born Tokyo 1942
Oh I am Precious #7, 1986
Necklace
Mizuhiki (paper cord) and canvas,
L. 10⅝ × W. 25¼ × D. ¼ in.
(27 × 64.1 × 0.64 cm)
2007.384.46
Pages 26–27

DOROTHEA PRUHL
Polish, born Wrocław 1937
Motten (*Moths*), 2000
Necklace
Wood and synthetic cord, L. 16 in.
(40.6 cm); D. irreg.
2013.602.11
Pages 88–89

WENDY RAMSHAW
British, born Sunderland 1939
Rings and stand, 1992
Rings: 18K gold and moonstone,
H. 1¾ × Diam. 1½ in. (4.5 × 3.8 cm)
Stand: perspex, L. 6 × Diam. 1⅜ in.
(15.2 × 3.5 cm)
N.A.2007.176a, b
Page 118

GERD ROTHMANN
German, born Frankfurt 1941
From My Fingertips, ca. 1988
Necklace
18K gold, L. 15½ in. (39.4 cm)
2007.384.47a, b
Pages 62–63

JACQUELINE RYAN
British, born London 1966
Kinetic, 2001
Brooch
18K gold, Diam. 2½ in. (6.4 cm);
D. irreg.
N.A.2007.177
Page 67

DEGANIT SCHOCKEN
Israeli, born Kibbutz Amir 1947
Brooch, 1987
Copper and silver, H. 6¾ × W. 6½ ×
D. ⅞ in. (17.1 × 16.5 × 2.2 cm)
2013.602.10
Page 122

JOYCE J. SCOTT
American, born Baltimore 1948
Night in the City, 1990
Necklace
Plastic and glass beads, laminated
photograph, fake suede, nickel silver,
and found metal parts, L. 16½ ×
W. 14 in. (41.9 × 35.5 cm); D. irreg.
2007.384.48
Pages 100–101

SONDRA SHERMAN
American, born Philadelphia 1958
Venus and Cupid, 1991–93
Necklace in two parts with fitted
case
Necklace: gold, glass, and silver
Front of necklace: L. 23 × W. 2 in.
(58.4 × 5.1 cm); D. irreg.
Back: L. 14½ × W. 8¼ in.
(36.8 × 21 cm); D. irreg.
N.A.2007.178a–c
Pages 72–73

VERA SIEMUND
German, born Essen 1971
Shadows, 2003
Necklace
Laser-cut brazed steel and enamel,
L. 17½ × W. 9½ in. (44.5 × 24.1 cm);
irreg.
2007.384.50
Pages 9, 97

PETER SKUBIC
Austrian, born Gornji Milanovac,
Yugoslavia 1935
Brooch, 1995
Stainless steel, enamel, cable
(tubing), lacquer, gold leaf, and
printed paper, H. 4¼ × W. 1¾ ×
D. 1¾ in. (10.8 × 4.5 × 4.5 cm); irreg.
2007.384.49
Pages 10, 59

KIFF SLEMMONS
American, born Maxton, North
Carolina 1944
Sticks and Stones and Words, 1992
Breastplate
Silver, pencils, erasers, stone,
horsehair, coins, and leather, H. 20 ×
W. 10 in. (50.8 × 25.4 cm); D. irreg.
2007.384.51
Pages 38–39

BETTINA SPECKNER
German, born Offenburg 1962
Brooch, 2000
Ferrotype, silver, and agate,
H. 3½ × W. 2¾ in. (8.9 × 7 cm)
2007.384.52
Pages 116–17

RACHELLE THIEWES
American, born Otowanna,
Minnesota 1952
Reflections of St. Mary's, 1995
Necklace
Silver, 18K gold, and slate
Pendant: L. 7¾ in. (19.7 cm);
W., D. irreg.
Chain: L. 23¼ in. (59.1 cm)
2007.384.54
Page 87

DETLEF THOMAS
German, born Niederrhein 1959
Necklace, ca. 1995
Oxidized silver wire and painted
metal, Diam. 10½ in. (26.7 cm); irreg.
N.A.2007.182
Page 90

EMMY VAN LEERSUM
Dutch, Hilversum 1930–1984
Amersfoort
Armband, ca. 1970
Resin, H. 2¾ × Diam. 2½ in.
(7 × 6.4 cm)
2007.384.55
Page 22

TONE VIGELAND
Norwegian, born Oslo 1938
Ring, 1994
Silver, H. 1¾ × Diam. 1¾ in.
(4.4 × 4.4 cm)
N.A.2007.183
Page 69

DAVID WATKINS
British, born Wolverhampton 1940
Gyro, ca. 1980
Bracelet
Aluminum, acrylic, and gold,
Diam. 4⅞ in. (12.4 cm)
2007.384.57
Page 68

SELECTED READINGS

Astfalck, Jivan, et al. *New Directions in Jewellery*. London: Black Dog Publishing, 2005.

Bernabei, Roberta. *Contemporary Jewellers: Interviews with European Artists*. Oxford and New York: Berg Publishers, 2011.

Besten, Liesbeth den. *On Jewellery: A Compendium of International Contemporary Art Jewellery*. Stuttgart: Arnoldsche Art Publishers, 2011.

Cheung, Lin, et al. *New Directions in Jewellery II*. London: Black Dog Publishing, 2006.

Cohn, Susan, et al. *Unexpected Pleasures: The Art and Design of Contemporary Jewellery*. New York: Rizzoli, 2012.

Dormer, Peter, and Ralph Turner. *The New Jewelry: Trends and Traditions*. London: Thames and Hudson, 1985.

Drutt English, Helen W., and Peter Dormer. *Jewelry of Our Time: Art, Ornament and Obsession*. New York: Rizzoli, 1995.

Greenbaum, Toni, and Martin Eidelberg. *Messengers of Modernism: American Studio Jewelry 1940–1960*. Exh. cat. Montreal: Montreal Museum of Decorative Arts; Paris and New York: Flammarion, 1996.

Ilse-Neuman, Ursula, and David Revere McFadden. *Zero Karat: The Donna Schneier Gift to the American Craft Museum*. Exh. cat. New York: American Craft Museum, 2002.

Joris, Yvònne G. J. M., and Ida van Zijl. *Private Passion: Artists' Jewelry of the 20th Century*. Stuttgart: Arnoldsche Art Publishers, 2010.

L'Ecuyer, Kelly H., et al. *Jewelry by Artists in the Studio, 1940–2000: Selections from the Daphne Farago Collection*. Boston: Museum of Fine Arts, 2010.

Le Van, Marthe. *21st Century Jewelry: The Best of the 500 Series*. Asheville, N.C.: Lark Crafts, 2011.

Lewin, Susan Grant, et al. *One of a Kind: American Art Jewelry Today*. New York: Harry N. Abrams, 1994.

Meilach, Dona Z. *Art Jewelry Today*. Atglen, Pa.: Schiffer Publishing, 2003.

Skinner, Damian, ed. *Contemporary Jewelry in Perspective*. Asheville, N.C.: Lark Crafts, 2013.

Snyder, Jeffrey B. *Art Jewelry Today 2*. Atglen, Pa.: Schiffer Publishing, 2008.

Strauss, Cindi, et al. *Ornament as Art: Avant-Garde Jewelry from the Helen Williams Drutt Collection*. Exh. cat. Houston: Museum of Fine Arts; Stuttgart: Arnoldsche Art Publishers, 2007.

Venet, Diane, et al. *From Picasso to Jeff Koons: The Artist as Jeweler*. Exh. cat. New York: Museum of Arts and Design; [Milan]: Skira, 2011.

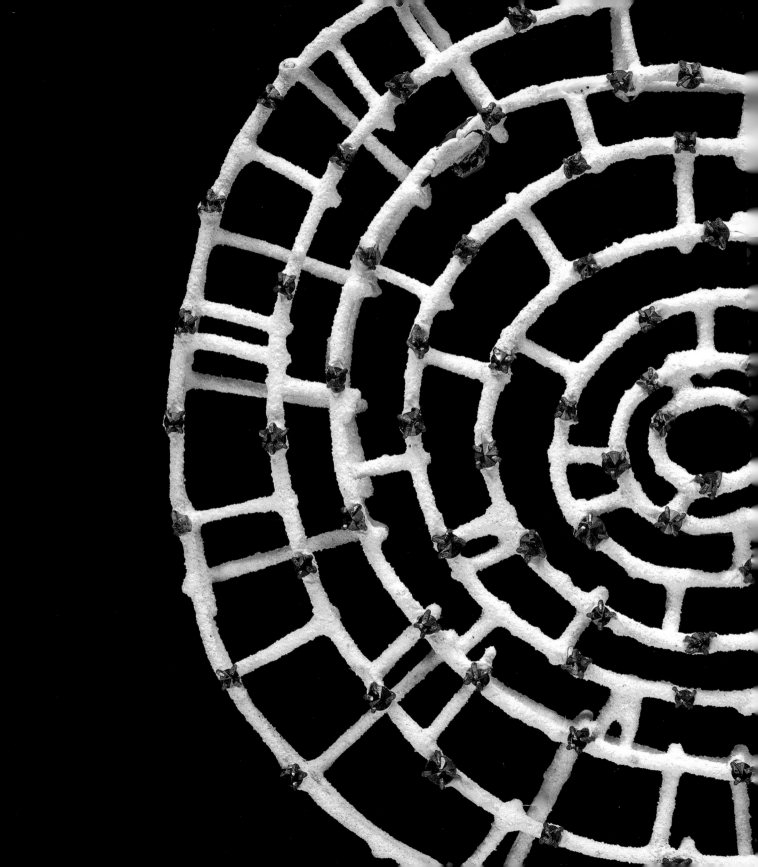